IMAGES
of America

WINDHAM AND WILLIMANTIC

IMAGES
of America

WINDHAM AND WILLIMANTIC

Ron Robillard

ARCADIA
PUBLISHING

Published by Arcadia Publishing
Charleston SC, Chicago IL, Portsmouth NH, San Francisco CA

Printed in the United States of America

Library of Congress Catalog Card Number: 2005920025

For all general information contact Arcadia Publishing at:
Telephone 843-853-2070
Fax 843-853-0044
E-mail sales@arcadiapublishing.com
For customer service and orders:
Toll-Free 1-888-313-2665

Visit us on the Internet at www.arcadiapublishing.com

CONTENTS

ACKNOWLEDGMENTS

This book represents less the work of the compiler than that of a number of other individuals, some of whom are unknown to me. The first thank-you goes to Lucy B. Crosbie, the former publisher of Willimantic's daily newspaper, the *Chronicle*, and an avid fan of, and great source of knowledge about, Windham history. Her personal collection of photographs and postcards constitutes the largest number of images in this book. Bev York, the curator of the Mill Museum, made available the museum's collection to me and was also an excellent source of information. The Windham Historical Society graciously allowed me to print photographs from its collection. For background information I relied on a number of sources, including Ellen D. Larned's *History of Windham County*, Allen B. Lincoln's similarly named 1920 history, and Norris G. Osborn's *History of Connecticut*. The most valuable sources of information by far were Thomas R. Beardsley's *Willimantic: Industry and Community, The Rise and Decline of a Connecticut Textile City*, and his series of local history columns written for the *Chronicle* over the past 13-plus years. Then there are the photographers. Some are well known, like F. E. Turner and Julian Beville. Their work shows best how Willimantic looked in the first decade of the 20th century. Some of the 1938 hurricane photographs were taken by Frank Crostwait. For the most part, however, the photographers remain anonymous. Yet without them, this book would not have been possible. A final thank-you goes to Robert Mathieu, who helped to identify some interior shots of the thread company.

INTRODUCTION

For readers unfamiliar with Windham and Willimantic, a note of explanation is in order. Connecticut consists of 169 towns, of which Windham is one. Willimantic is the developed section of Windham, a place of factories, stores, and apartment buildings in what otherwise remains a semirural town. As Willimantic outgrew the other sections of town in the early 1800s, it was separately incorporated as a borough in 1833 and as a city in 1893. In 1983, the city and town were reconsolidated under one government.

To further confuse matters, Windham consists of three distinct villages—Windham Center, South Windham, and North Windham—each with its own post office and two with their own libraries.

The first 150 years of history revolves around Windham Center, a robust community thanks to its being a stop on the stage road between Hartford and Providence and to the fact it was the county seat of Windham County.

Things changed dramatically after 1825, when Willimantic, earlier known as Willimantuck Falls, began to develop as the industrial center of town—although all three Windham villages were home to small industries. As Willimantic's textile industry grew, so did its influence relative to the three Windham villages. Eventually, Willimantic became a bustling, wealthy small city, somewhere between the tiny mill villages that dot eastern Connecticut and the much larger textile cities of Massachusetts and New Hampshire.

When photographers visited the area, it was Willimantic they were interested in: the large factories, the street scenes, and the social events. That is why this book contains more images of Willimantic than of other sections of Windham.

Organizing a book such as this involves making choices. Should the story be told chronologically or thematically? The long history of this town—300 years' worth—posed additional issues. I chose an approach that incorporated both time and subject, and divided the book into seven chapters.

The first chapter, entitled "The Windhams," deals primarily with the earliest history of the town while touching briefly on some 19th-century industries.

The second chapter, "The Mills," focuses on the development of what later became Willimantic's primary industry: textiles. Although both silk and cotton cloth were manufactured here, the city's fame ultimately rested on its sewing thread, a specialty sector of the overall textile industry. The original name of Willimantic's famous thread manufacturer was the Willimantic Linen Company. Linen is made from flax, but the company maintained the name

for decades after it had switched over all its production to cotton. It was later renamed the Willimantic Thread Company. Ultimately, with the help of British financiers and the merger of more than 60 companies, it became the American Thread Company.

The third chapter, entitled "From Village to Small City," shows the evolution of Willimantic as factories were added and housing and stores spread westward along the valley of the Willimantic River.

The fourth chapter, "Public Edifices," looks at some of the buildings that made Willimantic a regional center for transportation, trade, education, and health care for more than a dozen surrounding communities.

The fifth chapter, "Downtown," takes a closer look at some of the buildings along Willimantic's Main Street and the retailers and theaters that brought the town to life.

The sixth chapter, "Life in a Small City," examines the everyday affairs of all the social classes and the activities that brought them together. There was work, of course, and home life. There were outings and fairs, ice-skating in the winter, horse racing in the summer, school, clubs, and sports. Occasionally, there were difficult times: seeing troops off at the local depot or the 1925 strike that sharply divided the city. There were also parades. Windham, especially Willimantic with its broad Main Street, has always loved a parade. From the 1915 Old Home and School Day parade to the present-day Boom Box Parade, there is something about music and neighbors marching that stirs pride in place.

The last chapter is called "Wind, Rain, and Fire." Like any other town, Windham has suffered its share of disasters. From mishaps like a trolley skipping the tracks to fires that destroyed whole blocks of buildings, to record-setting floods and hurricanes, the town has seen it all and survived.

The textile industry is long gone. Yet the inventiveness and the spirit of entrepreneurship that created industry out of wilderness lives on as the city reinvents and reinvigorates itself. The old thread mills have been partly renovated as office space, and soon artists will live and work in another building where once textile machinery clunked and whined. Thousands of students from around the state and the world come to Windham each year to attend one of the town's two colleges or the University of Connecticut, seven miles away in Mansfield. A state airport with a nearly one-mile-long runway serves the northeastern corner of the state, and unlike many cities in Connecticut, freight trains still rumble through town daily.

Windham and Willimantic are steeped in history. A frog that is based on an 18th-century legend and a spool of thread that is symbolic of the once dominant industry adorn the town seal. Yet as much as residents appreciate the past, they anticipate the future.

One

THE WINDHAMS

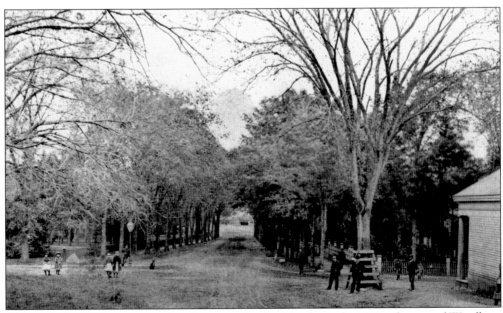

Although the Willimantic section became urbanized in the early 1800s, the rest of Windham remained largely rural. There was not much to do except stand around and gawk at the photographer when he visited Windham around 1900. Two centuries of history have been reversed in the last decade, as Willimantic has lost residents and the other sections of town have grown.

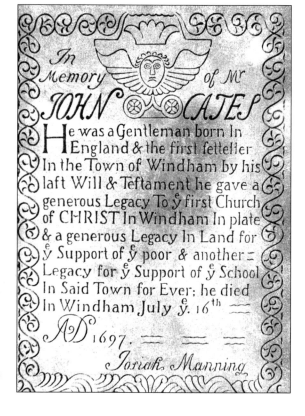

Windham occupies land given to 16 Englishmen by Joshua, the son of Mohegan Chief Uncas. Joshua's 1675 will deeded the Englishmen the land for their help in defeating the Mohegans' archenemy, the Pequots. Today, the original copy of Joshua's will is in the town clerk's vault. As for the Mohegans and Pequots, they are still competing. Each tribe operates a major casino about 20 miles south of Windham.

This memorial tablet in Windham Cemetery marks the burial place of John Cates, the first English settler in Windham. Cates and a black servant, Joe Ginne, built the first house in town in 1689. Cates lived until 1697. When he died, he gave a portion of his estate to the church and the town.

When artist John Warner Barber visited Windham around 1835, he wrote, "The houses are more clustered together than in most New England villages of the same period and it has been remarked by travelers, that Windham, in its general appearance, very much resembles an English village." He also noted that Windham Center "has somewhat declined" since the establishment of "the flourishing village of Willimantic."

Windham Center was the most prosperous section of town in the early years, and many fine homes were built there, including this one owned by Col. Jedediah Elderkin. Elderkin was a town selectman and served as the state's attorney. During the Revolution, he operated a gunpowder mill at Willimantuck Falls.

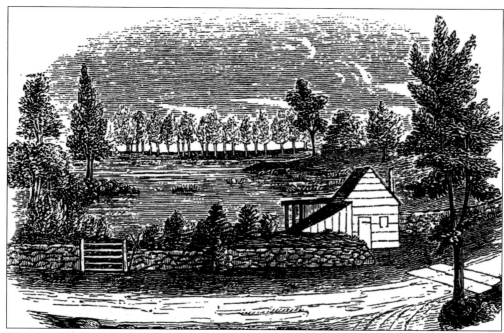

This is artist John Warner Barber's view of Frog Pond in Windham. Hideous noises awoke residents one summer night in 1758 during the French and Indian War. Fearing an attack, residents gathered outdoors and waited until daybreak. A scouting party the next morning discovered the source of the noise. It was not Indian war whoops they had heard but the deep-throated groans of bullfrogs battling for one of the remaining puddles of a pond drained by summer drought.

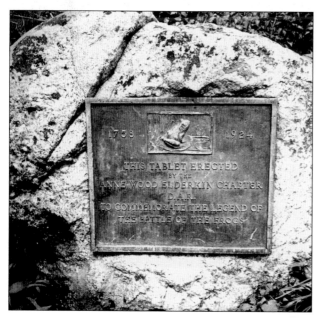

The story of the frog battle was an embarrassment for Colonial residents. The legend inspired stories, a poem, postcards, and even a light opera. Good-natured residents endured the ridicule, and today, a frog is incorporated in the town's official seal, and four bronze statues of frogs stand post at each corner of the main bridge entering town. This roadside monument commemorating the "battle" was erected in 1924 by the Daughters of the American Revolution.

Four British soldiers captured during the Revolution literally whittled away the hours during their imprisonment at Windham's jail by carving this statue of the Roman god Bacchus astride a keg. When they escaped, the county sheriff was fired. The statue was later used as a tavern sign. The statue can be seen today at the Windham Center Free Library.

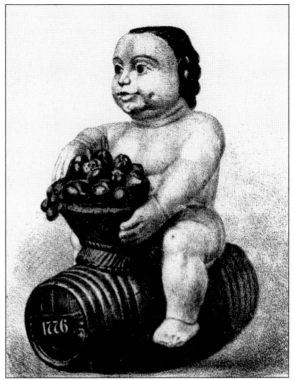

Windham Green stands at the crossroads that connected the town to Norwich in the south, Hartford in the west, and Providence in the east. This late-1800s view of the intersection features the columned Windham National Bank. The bank was built in 1832. It remains in use today as the Windham Center Free Library.

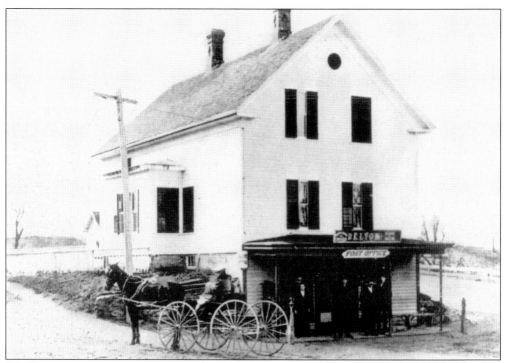

Rural free delivery (RFD) began as an experiment in 1896, shortly before this view of the North Windham Post Office was taken. Until RFD, customers had to go to the post office to get their mail. Most post offices were maintained by the owners of stores like Deylon's as a sideline, providing a public service while acting as a draw for customers.

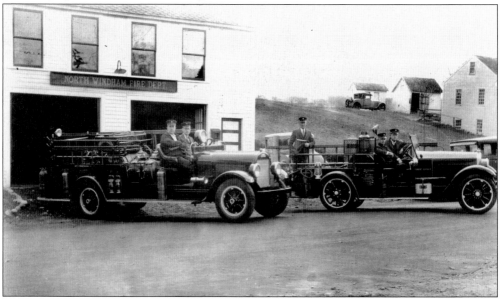

These North Windham fire volunteers proudly show off their new truck in 1931. Windham has four fire companies. The ones in the North Windham, South Windham, and Windham Center are volunteer departments. Willimantic has a full-time, paid fire department, which also operates the ambulance service for the whole town.

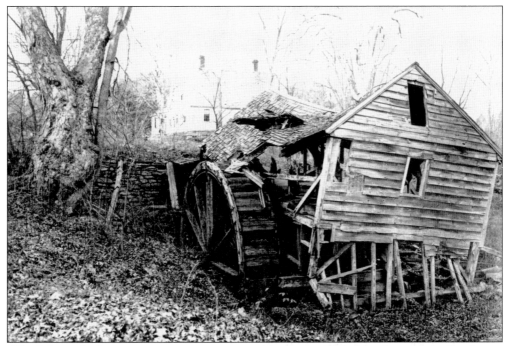

All of the early factories in town were powered by waterwheels like the one on this former gristmill on Lovers Lane. The first mill in town was a sawmill, built in 1706. The first gristmill followed in 1710. By the time the age of packaged goods had arrived at the end of the 19th century, the old mills had fallen into disrepair.

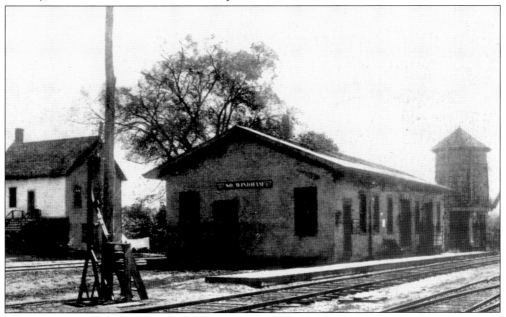

This shot of the Central Vermont freight depot in South Windham was probably taken between 1890 and 1919. Note that tracks run on both sides of the building, and notice the water tower in the background. The depot served manufacturers like the American Wood Type Company and Smith and Winchester.

C. H. Tubbs owned the American Wood Type Company in the late 1800s. The company occupied the former factory of Edwin Allen. Allen, a cabinetmaker by trade, devised a way to mass-produce wood type. Wooden fonts were traditionally cut by hand, but Allen invented a machine that cut the typefaces with a die. Wood type was preferred for the largest sizes because cast-metal type did not print evenly due to its concave surface.

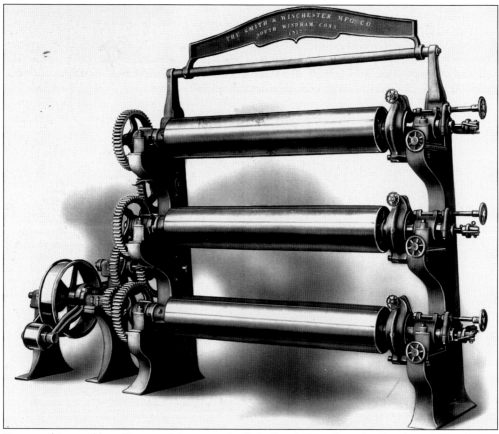

Paper making and handling machinery was built in South Windham by Smith and Winchester Company for a century. Paper was handmade until the invention of the Fourdrinier machine in 1803. The first Fourdrinier machine imported to America was installed in North Windham. The installer, George Spafford, considered importing more machines but decided instead to manufacture his own. Charles Smith and Harvey Winchester bought him out in 1837, and operations continued until the early 20th century.

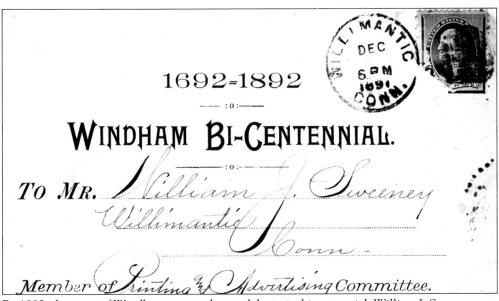

By 1892, the town of Windham was ready to celebrate its bicentennial. William J. Sweeney, not surprisingly, was a member of the bicentennial printing and advertising committee. Sweeney owned a stationery store in downtown Willimantic that also sold books, periodicals, and wallpaper. As a sideline, Sweeney owned a transatlantic ticket agency.

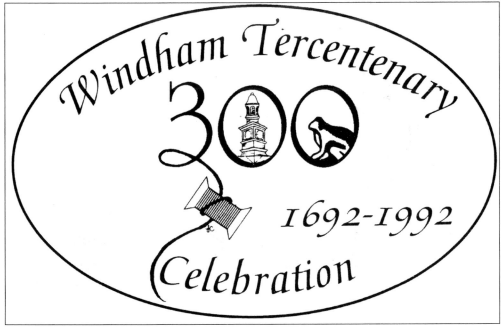

The logo for the town's 1992 tercentennial celebration incorporated three icons familiar to all those who know the town and its history. The numeral three is extended to wrap around a spool of thread, a reminder of the days when Willimantic was known as America's Thread City. The first zero includes the unique copper-capped tower of the town hall, and in the second zero is a stylized frog, hearkening back to the famous frog battle.

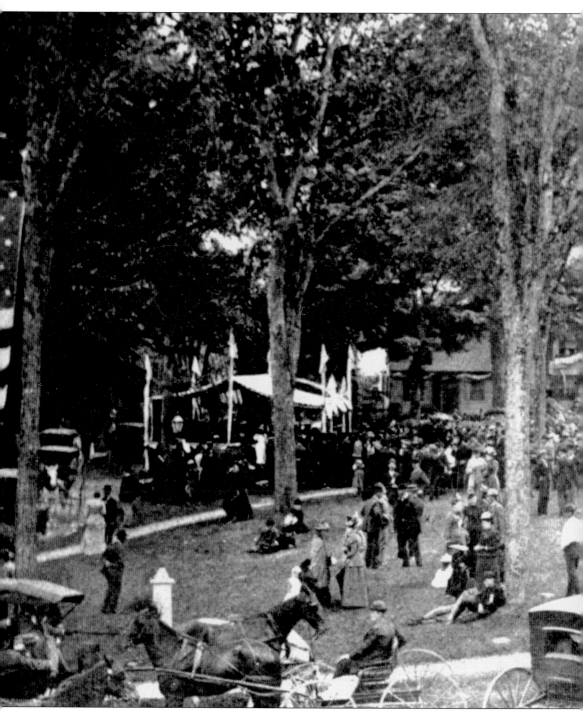

The celebration of the town's bicentennial almost did not happen, according to one text. When warring Protestant factions failed to agree on the planned celebration, a Catholic missionary, Rev. Florimond DeBruycker stepped in. DeBruycker had come to Windham in 1863 to serve the Roman Catholic immigrants working in Willimantic's textile mills. A forceful character, he managed over the next 40 years to build a church (St. Joseph), a parochial school, a convent, a

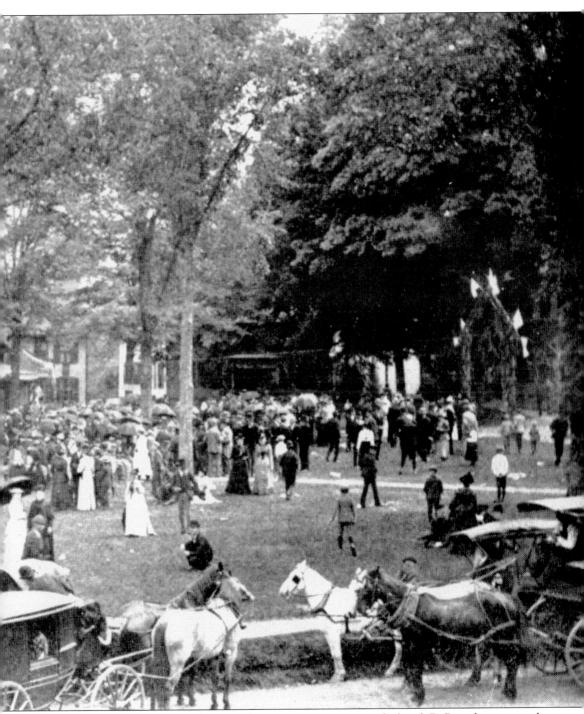

cemetery, and a hospital. He also started a temperance society and a band. DeBruycker managed to pull the bicentennial celebration together on June 8, 1892, at the Windham Center Green. The celebration started with the boom of cannons and the peal of church bells. The day was filled with speeches, music, and other performances.

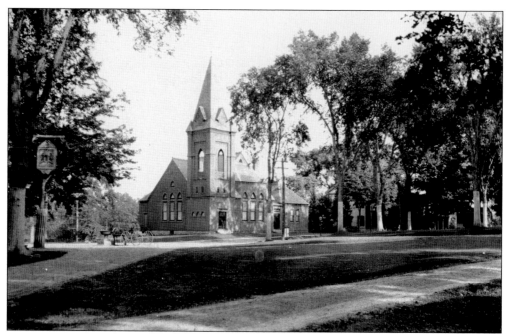

In this shot of the Windham Center Congregational Church, a buggy can be seen and the roads are unpaved. The church is one of two in Windham Center. The other is St. Paul's Episcopal Church, home to two paintings by impressionist J. Alden Weir, whose wife was a Windham native. *The Village Factory*, by Weir, is a scene of Willimantic's thread mills and is in the collection of the Metropolitan Museum of Art in New York City. Weir is buried in Windham.

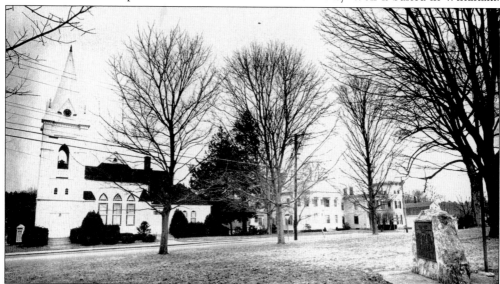

The Congregational church can be seen in this modern photograph of Windham Center. The homes behind it are representative of the number of architectural styles found in Windham Center. The monument in the foreground is a memorial to veterans. From the French and Indian War through the Revolution, the Civil War, the Spanish-American War, two world wars, the Korean War, the Vietnam War, and the Mideast conflicts, Windham residents have answered the call of their country.

Two

THE MILLS

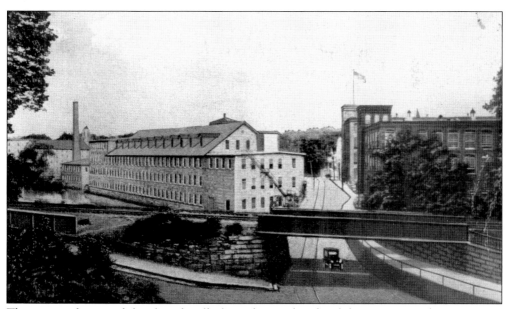

This postcard view of the thread mills from the south side of the river was taken sometime after 1903, the year trolley service began in the city. The car under the railroad bridge has just crossed Jillson Bridge and is headed toward Pleasant Street.

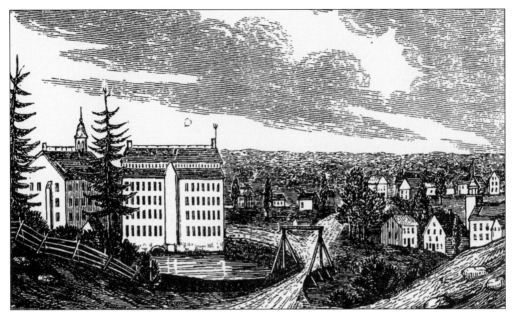

When John Warner Barber captured this view in 1835, this area of town was already called Willimantic. In Colonial days, it had been called Willimantuck Falls. When Barber visited, the village of 2,000 was on the verge of a growth spurt. It consisted principally of one main street on the northern side of the Willimantic River and was home to three congregations: one Congregational, one Methodist, and one Baptist.

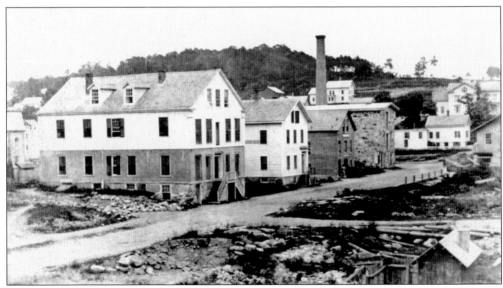

Shortly after John Warner Barber's etching, the city began to grow. The Holland Manufacturing Company was built on the corner of Church and Valley Streets in 1865. The firm made silk thread and employed 50 workers. A second mill was built in on Church Street in 1873. Interestingly, many of the city's silk mills—Holland, Turner, Brown & Son, and Windham Silk—were located north of Main Street while cotton mills dominated the south side.

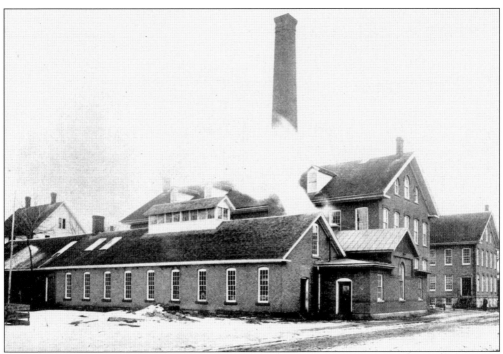

This later view shows the Holland Mills. The company kept sales offices in New York, Philadelphia, and Boston. It operated in Willimantic until the Great Depression, when an argument over property taxes prompted Holland to look elsewhere. The city cut the company's taxes by $40,000, but Holland ended up moving anyway to Stroudsberg, Pennsylvania, in 1934.

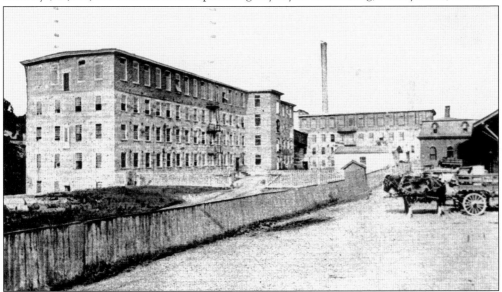

Charles Lee built this cotton mill east of Bridge Street in 1822. The buildings housed a number of companies over the years, including the Smithville Company and Willimantic Cotton Mills. The Smithville Company was the first in the nation to make cotton thread, but Coats Cotton of Great Britain sued for patent infringement, and the company returned to making cloth. Windham Manufacturing Company eventually took over the buildings.

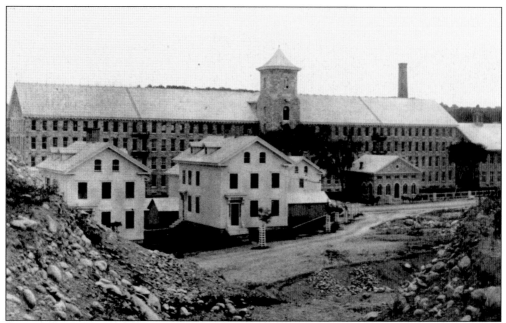

The penciled notation on the back of this photograph reads, "ATCO Mill No. 2, construction of village." ATCO refers to the American Thread Company, the successor of the original Willimantic Linen Company. As part of the project, the company built a boardinghouse, moved and fitted out houses for tenements, and built 18 duplexes to house workers.

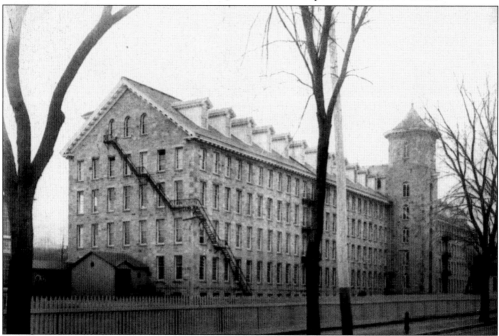

The Willimantic Linen Company's Mill No. 2 was begun in 1863, after the company announced it would build a factory 640 feet in length. A local stone smith built an 18-foot-high dam of granite quarried from the riverbed behind the mill. The project was slowed by a bad winter and two labor disputes. The dormers were later removed.

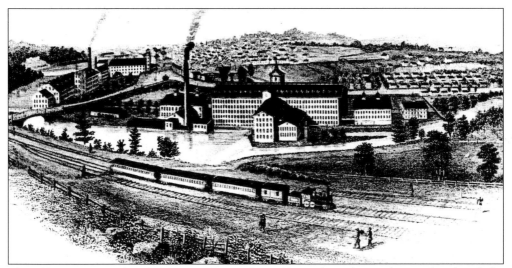

This illustration produced for a magazine shows the rail track on the south side of the Willimantic River in the foreground, the dam behind Mill No. 2, and at the far left, the Jillson stone arch bridge, one of two stone arch bridges in town. Worker housing dominates the middle right, and the development of Prospect Hill as the city's premier neighborhood is visible in the upper left.

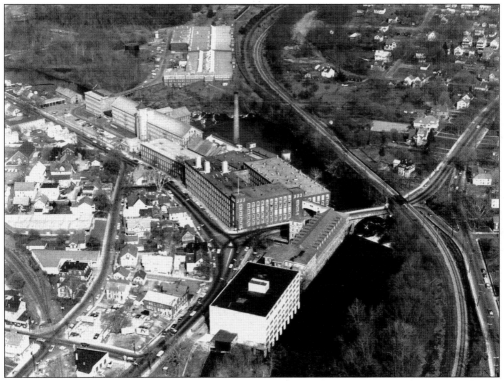

Taken from the opposite direction, this modern aerial view shows the scope of the American Thread Company complex. Here, the stone arch bridge is in the foreground, and the rail tracks can be seen to the right of the river. Behind the granite Mill No. 2, with its distinctive tower, is Mill No. 4, on the opposite side of the river. Mill No. 4 was destroyed by fire in 1995.

The thread company kept its own stables across Main Street. The company strove to be a self-reliant and fully integrated manufacturer. In addition to the stables, the company owned a separate company to make its spools, did its own bleaching and dying, and operated a print shop.

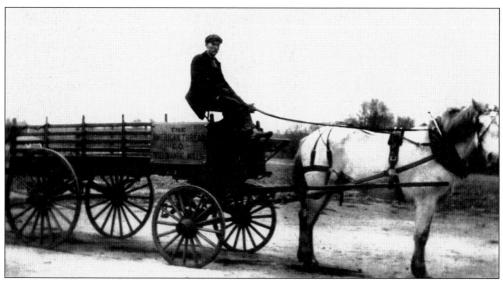

This photograph of a driver with his horse and wagon was taken sometime after 1908, the year the American Thread Company took over Willimantic Thread Company. Note the American Thread Company sign underneath the driver's seat.

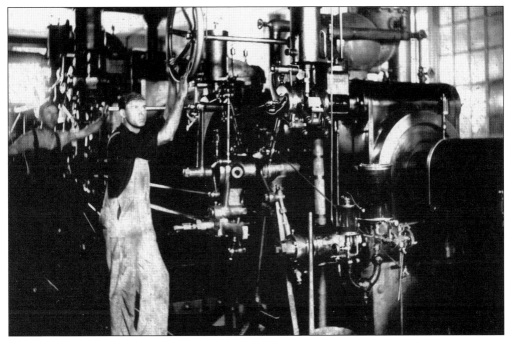

Robert Mathieu, a plumber for 45 years at the thread company, identifies this scene as part of the dye shop. The machine was used to dye yarn, an improvement over the old dip tubs previously used.

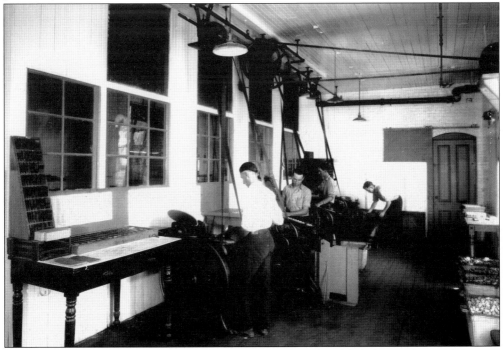

The thread company printed its own spool labels on these hand-fed presses. Cases of type can be seen on the table at the left. Note the belt across the ceiling to a large centered pulley that drives a shaft and smaller pulleys that power the presses underneath them.

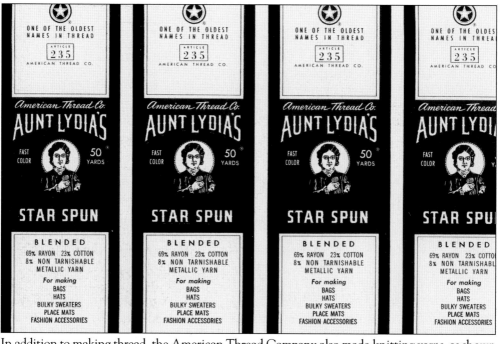

In addition to making thread, the American Thread Company also made knitting yarns, as shown in this uncut strip of skein labels. Rayon, the first artificial fabric, was invented in 1855 as a substitute for silk. These labels are post-1924, the first year "artificial silk" was called rayon.

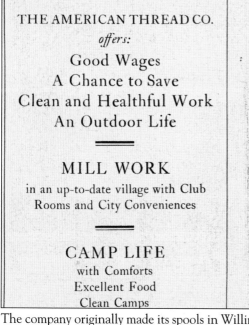

The company originally made its spools in Willimantic, but to ensure a constant supply of birch it opened a spool plant in Maine. This recruitment brochure touts the benefits of country life with city comforts. The "excellent food, spring beds and mattresses, and bath tubs" mentioned in the brochure were apparently not enough to lure workers. One employee recalled years later that the average age of workers at the Milo plant was 73.

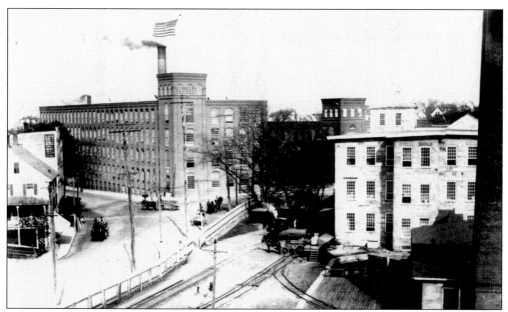

This is Thread Mill Square, where Main Street meets the road that connects Willimantic to the south side of the city across the river. Note that the rail tracks here are completely in the mill yard. They were part of the private rail system set up by the American Thread Company to connect all the buildings on the massive site and to facilitate the movement of goods from building to building.

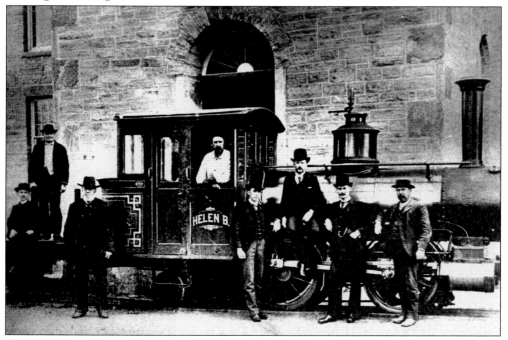

The company train was pulled by an engine named the *Helen B*. Helen was the daughter of Eugene Stowell Boss, who rose from bookkeeper of the Willimantic Linen Company to become mill agent, the equivalent of a modern-day plant manager. Boss was known around town as "General Boss."

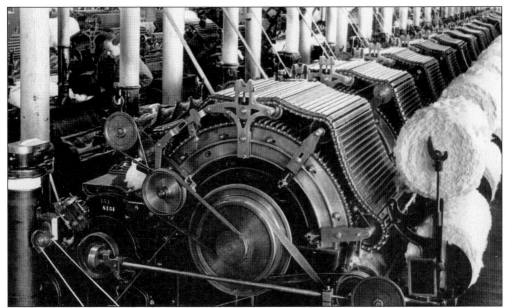

One of the first steps in making textiles is carding. These carding machines untangle the fibers of raw cotton and pick out seeds and other impurities. When textiles were a home industry, carding was usually the job given to children, who used metal combs to card the cotton. The introduction of a mechanical carding machine set the stage for mass production. Carding was also known as combing.

Coming off the back end of a carding machine is an untwisted strand of fiber called a sliver (pronounced with a long *i*). The cotton is now ready to be spun or drawn out into long, thin filaments.

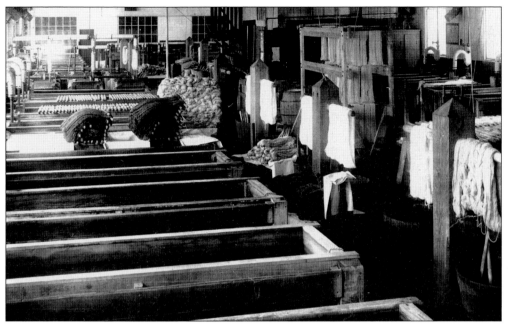

This was part of the American Thread Company bleaching and dying operation, shown in a 1918 photograph. Large skeins were dipped in the wooden tubs and then hung to dry. So many textile companies sent out their goods to be bleached or dyed that the federal Census of Manufactures counted bleaching and dying as a separate sector within textiles.

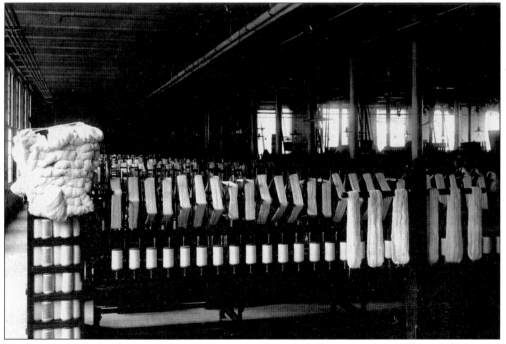

The writing on the back of this 1918 image identifies these American Thread Company machines as "swift spoolers." Spoolers, also known as skein winders or coners, took large skeins of fabrics and transferred them to cones or large spools.

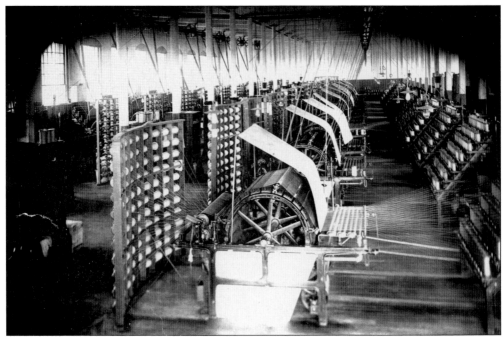

In the dressing room, the twisted yarn or thread was pulled to proper tension to ensure the twist held together, brushed to remove fuzz, and sized to give it a slight gloss. Robert Mathieu said the thread company used a combination of cornstarch and wax for sizing.

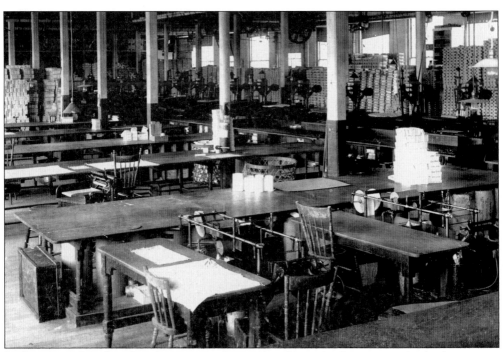

Packers sat at these long benches, putting the spools in boxes for shipment to the final customer. Piles of boxes can be seen against the back wall.

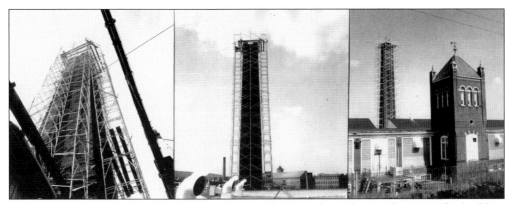

These three photographs show the construction of the smokestack at Mill No. 4. The building was the first textile factory in the country designed to be lit by electric lights. The company had always generated its own power, but a new coal-fired power plant was built south of the river to accommodate the new factory.

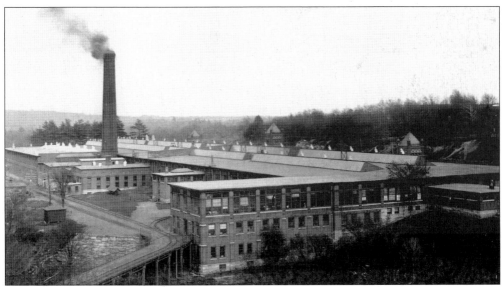

Local legend has it that Thomas Edison was on hand in September 1880 for the opening of Mill No. 4, but newspaper accounts do not mention his name. The legend may partly be based in the fact that Austin C. Dunham, the mill's president and an engineer himself, knew Edison. Former president Ulysses S. Grant, however, did visit the mill in October 1880. Dunham pioneered the use of electric arc lighting in Mill No. 2.

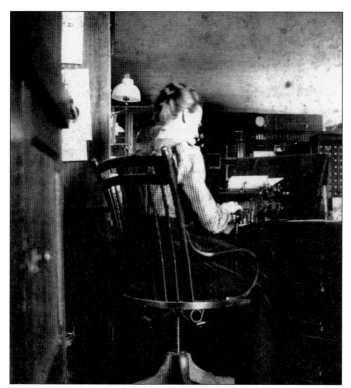

Besides mill operatives and the employees in the ancillary operations, the thread company relied on an office staff to handle sales, ordering, inventory, payroll, and bookkeeping. The penciled inscription on this picture says, "ATCO office worker G.B.C." A researcher has identified her as Gertrude B. Crane.

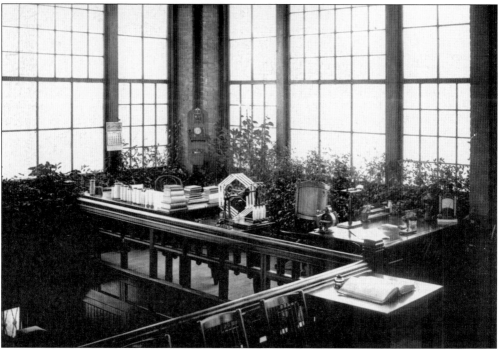

Not all the office staff worked in cramped corners and at crowded desks. The superintendent's office in Mill No. 4 offered an airy view and had stained-glass windows, plants, and a commodious desk. Note the spools of samples on the table.

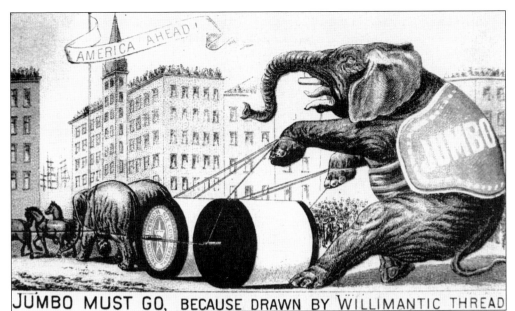

JUMBO MUST GO, BECAUSE DRAWN BY WILLIMANTIC THREAD

The thread company believed in marketing and promotion. One historian writes that newspaper reporters were always welcome in Willimantic. The company produced a sewing magazine and booklets for schoolchildren. For 24¢ in postage, a child could get a booklet and six spools of thread. The company also produced a number of trade cards. Here, even the mighty Jumbo cannot stand still when he is pulled by Willimantic thread.

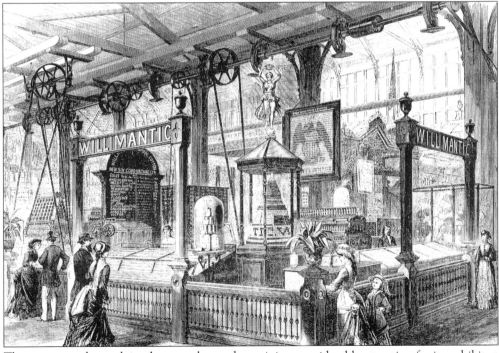

The company also took its show on the road, receiving considerable attention for its exhibit at Philadelphia's Centennial Exhibition in 1876, where its large booth displayed the company's six-cord thread made especially for sewing machines.

New England's textile industry peaked in 1919 and then began a long, slow decline that included a series of strikes in the 1920s, the Great Depression through the 1930s, and devastating floods in the 1950s. Many companies, strapped for cash during the Depression, began to sell nonindustrial holdings such as worker housing. This handbill advertises a 1938 auction to dispose of thread company housing.

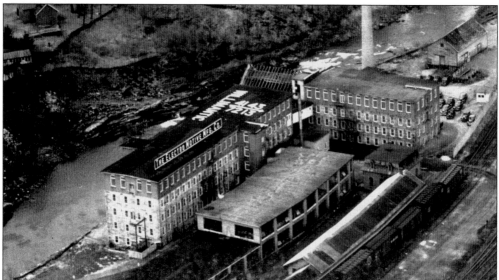

When the Quidnick Mills (formerly Windham Manufacturing) on Bridge Street closed in 1926, more than a century of cotton cloth manufacturing came to an end. The west mills were taken over by a new company, Electro Motive, which made electrical controls. The firm eventually built a new plant on the other side of the river, but it too has now ceased local operations.

36

Three

FROM VILLAGE TO SMALL CITY

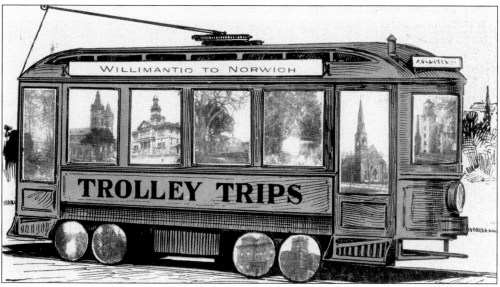

Willimantic had been a rail center for nearly half a century, but the coming of trolleys in 1903 opened a new era of personal transportation. This card, postmarked 1911, includes photographs of prominent Willimantic buildings in the windows of a cartoon trolley car. They include the double-spired St. Mary Church, Windham Town Hall, one of the Elderkin family houses, a bucolic scene, and the Willimantic Congregational Church.

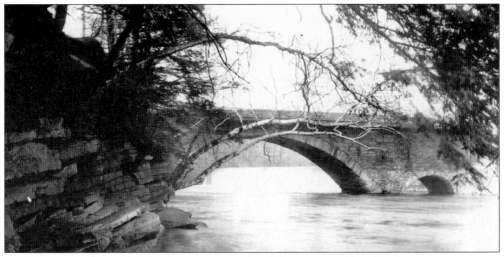

As Willimantic grew, easy access from one side of the river to the other became paramount. The answer was two stone arch bridges at opposite ends of Main Street. The Windham Road Bridge, also known as the Jillson Bridge, was built by the thread company in 1857. Another bridge was built upriver by local stonemason Lyman Jordan in 1868. At 80 feet in length, it is the third-longest stone arch bridge in the state.

Thread mill treasurer William E. Barrows responded to a huge tax increase in 1877 by opening a store to compete with local merchants. The effort was unsuccessful, and in 1884, the store was leased to a Manchester merchant. After several operators failed in the location, the company used the lower two floors for offices. The third floor remained a company-sponsored library until 1941. Today, the building houses the Mill Museum.

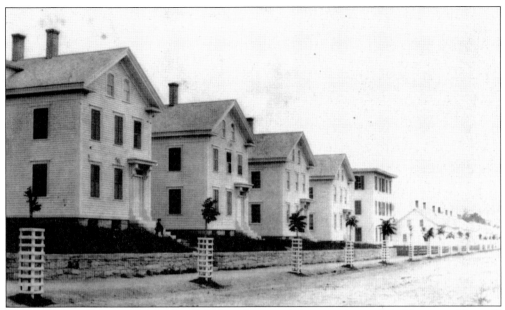

Willimantic's growing industry demanded workers, and those workers needed housing. The mill owners provided it. The early city was really a conglomeration of neighborhoods built around separate mills: Smithville, Richmond Town, Jillson Hill, Leesburg, and Tingleyville. Workers called this neighborhood Threadsville, but the linen company named it Iverton in honor of Lawson Ives, a local textile pioneer.

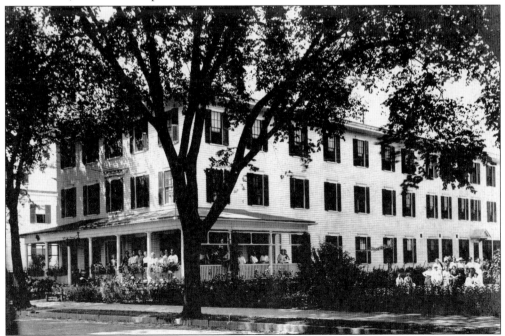

In addition to housing for families, the thread company erected the Elms, a three-story boardinghouse measuring 95 by 45 feet, to house single female employees. The front of the house originally faced east, but the company had it turned 90 degrees so that it faced the great granite Mill No. 2 across the street.

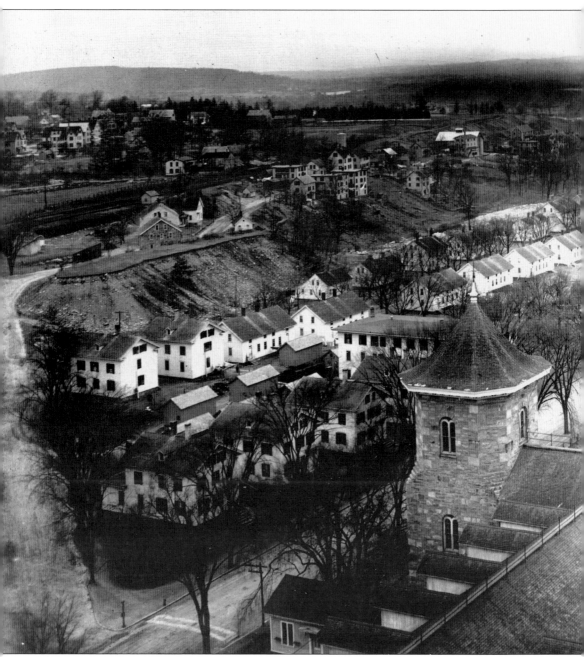

This view looking east was taken from atop the smokestack of Mill No. 2 by photographer F. E. Turner. Turner used the occasion to take sweeping panoramic views of the developing city. In this view, the boardinghouse is the fifth house on the right facing Main Street. Behind it stretches the village of Iverton. Most of the land beyond is still undeveloped. The Natchaug

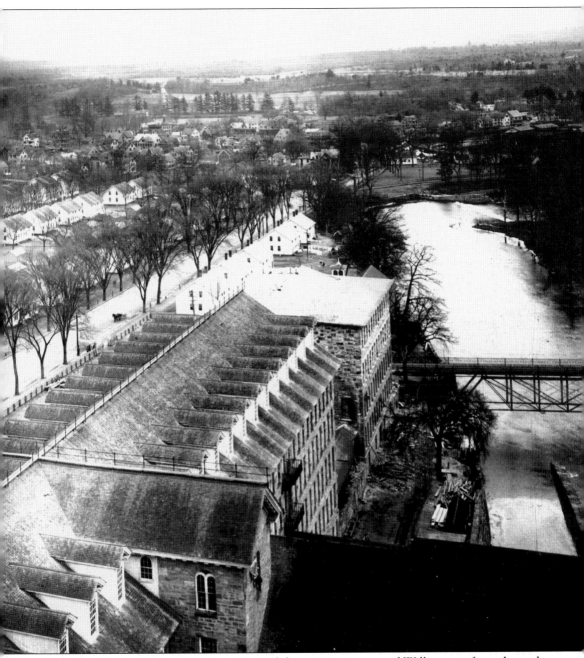

River can be seen in the distance. Many of the existing images of Willimantic from the end of the 19th century into the early years of the 20th century were made by Turner and Julian Beville. Beville took a similar series of photographs from the smokestack of the Windham Manufacturing Company at the western end of Main Street.

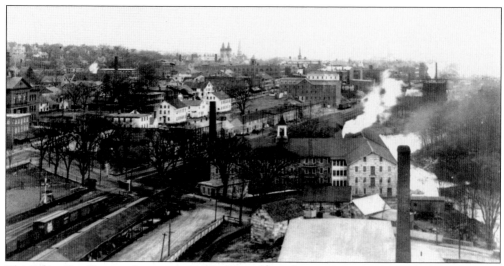

This Julian Beville view from atop the Windham Manufacturing Company stack also looks east. Bridge Street separates the former Smithville Manufacturing Company from the Windham Company. To the left of both mills are the railroad tracks. In the far distance are the twin spires of St. Mary Roman Catholic Church and, beyond, the steeple of St. Joseph Roman Catholic Church.

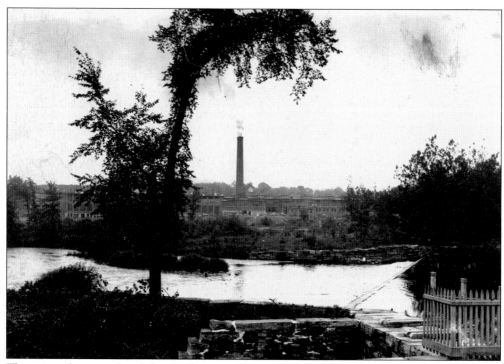

This view from south of the Willimantic River dramatically demonstrates how the mills dominated the town. Despite the trees and picket fence in the foreground, industrialism and the class system that came with it were never far from the consciousness of Windham's residents.

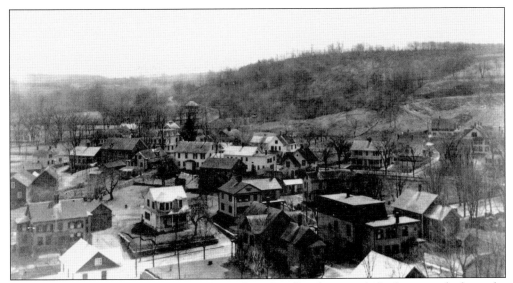

Hosmer Mountain can be seen in this Julian Beville photograph looking south from the Windham Manufacturing Company. Shown is the growth of the city on both sides of the Willimantic River. Partway up the mountain, in the upper right, the stonework around the city's original reservoir can be made out.

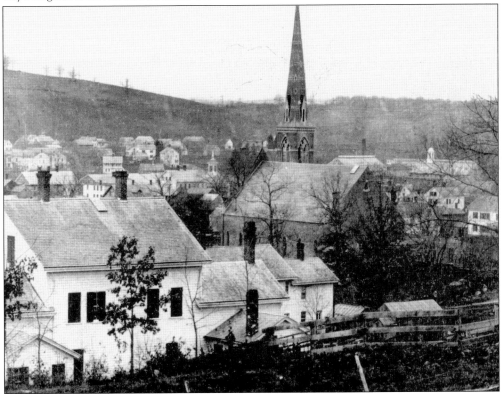

This view was probably taken from partway up Prospect Hill, looking back toward the city. The Willimantic Congregational Church, at Valley and Walnut Streets, can be seen from the rear. The image clearly shows how far west Willimantic had spread.

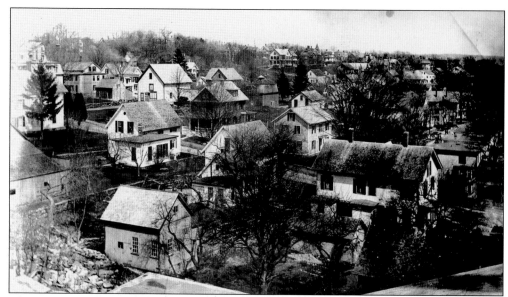

This Julian Beville view north of Main Street and east of High Street shows the modest single-family homes and small lots typical of city development. Some of the larger Victorian-style mansions of mill owners and merchants that later dominated Prospect Street can be seen along the top of the hill in the background.

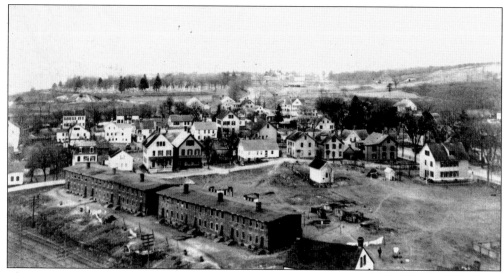

This was the western edge of Willimantic in 1909 that photographer Julian Beville saw from his perch atop the smokestack. Mansfield and Windham Streets have yet to be laid out. The row houses in the foreground are housing for mill workers. What is now West Main Street is undeveloped land.

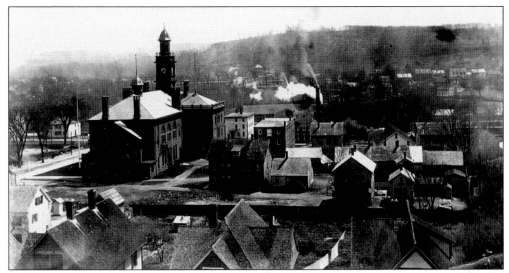

The side and rear of Willimantic Town Hall is seen here from the northeast. High Street runs alongside it to the Main Street intersection. It took nearly 10 years of meetings and referendums before voters gave the go-ahead to move municipal offices from rented space on Main Street into their own building. When completed in 1896, the building housed town offices and the county courthouse. The clock in the tower still runs—with some help.

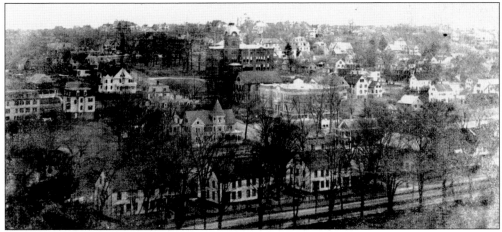

The large square building with the corner tower and domed roof in the center of this photograph is the Willimantic Normal School. The state normal schools prepared elementary teachers. Willimantic was in competition with Norwich for the school, but the donation of a plot of land on Valley Street by the Windham Manufacturing Company cinched the deal.

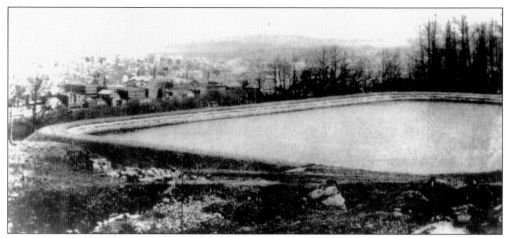

The booming city can be seen across the river in this view from the Hosmer Mountain Reservoir. Willimantic got its first public water supply in 1885. Water was pumped three miles from the Natchaug River to the reservoir on Hosmer Mountain. At an elevation of 300 feet over the milldams, gravity feed ensured good water pressure to all buildings in the city.

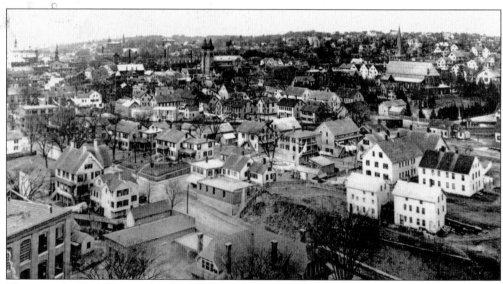

This view by F. E. Turner clearly shows a number of city landmarks. The four chimneys and roof of the former mill store can be seen in the foreground. The building at the right with the steeple and the rounded back is St. Joseph Church. Barely a block to the left is St. Mary Church, founded by French Canadian immigrants who did not get along with the Irish who dominated St. Joseph.

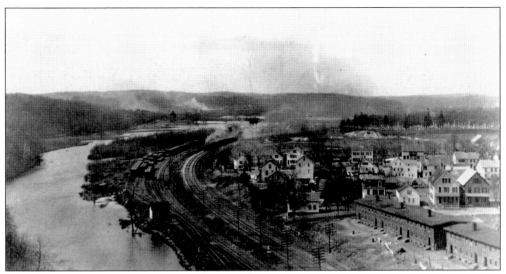

This view by Julian Beville looks west from the Windham Manufacturing Company at the rail yards on the western edge of the city. An approaching train throws off a plume of smoke. Willimantic Cemetery can be made out in the distance.

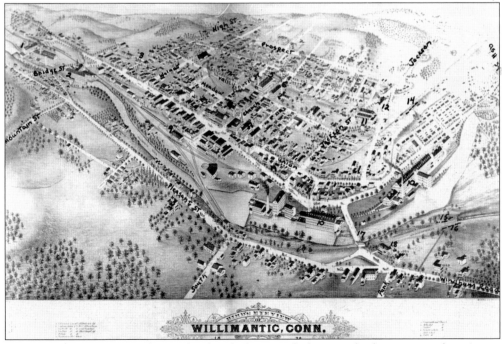

Bird's-eye views were popular in the days before aerial photography became a reality. Artists specializing in the views traveled from city to city, turning out hundreds of scenes. In this 1876 view, High Street still marks the western boundary of the city. Someone wrote in the street names at a later date. They were not part of the original print.

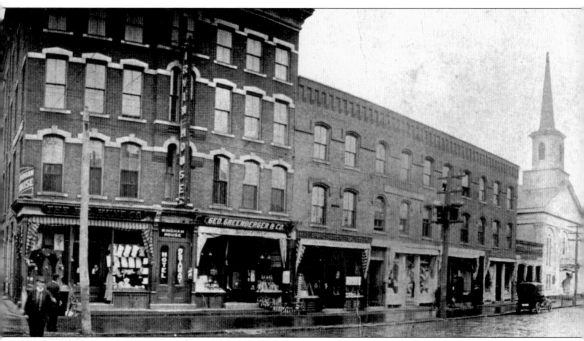

This scene is from a section of a single stereograph view taken of Main Street in 1916. The photograph shows Lincoln Square, where Main and Union Streets intersected. The intersection no longer exists, having fallen victim to redevelopment in the 1970s. The $11 million redevelopment project, approved in 1971, affected 38 acres of downtown land and displaced 291 families and 171 businesses. Although some new construction came out of the project, such as the Willimantic Fire-Safety Complex and the WILI Radio building, the

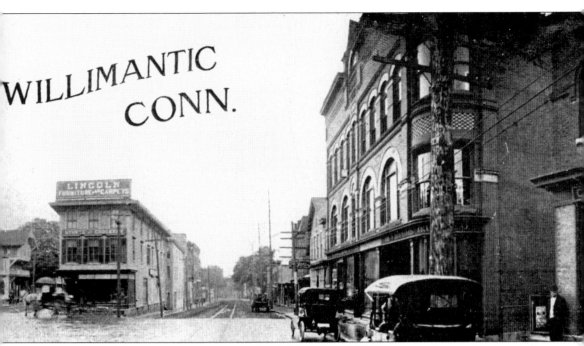

WILLIMANTIC CONN.

centerpiece of the project never materialized. Plans for a 120,000-square-foot pedestrian mall fell through when the East Brook mall was built in 1975, just across the town line in Mansfield. The land once projected for the mall has been vacant since, used for carnivals, balloon festivals, and the staging area for the town's annual Boom Box Parade. In 2003, residents voted against developing what had become the city's unofficial town green and keep the land a park as a refuge for downtown workers and residents.

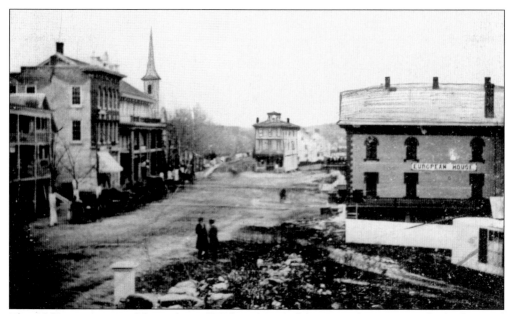

This 1860s view is one of the earliest of Willimantic. It shows Lincoln Square in the background and the spire of the Baptist church to the left. Two people stand in front of what appears to be a vacant lot adjacent to the European House, one of the city's early hotels. On the far side of the hotel is Railroad Street. WILI Radio's studios now occupy the former hotel site.

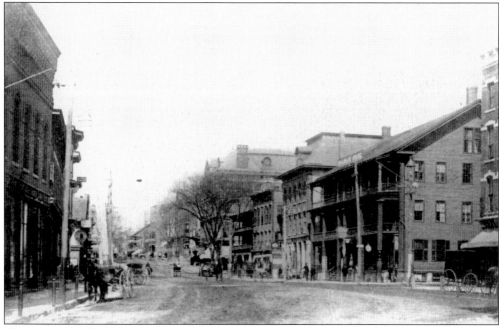

This view of Willimantic's Main Street shows the Brainard House (the building with porches) on the right. Built by Sheffield Lewis in 1848, the Brainard House originally had retail stores on the ground level with apartments above. Henry Brainard bought the block in the 1850s and converted it into a hotel to serve the growing community.

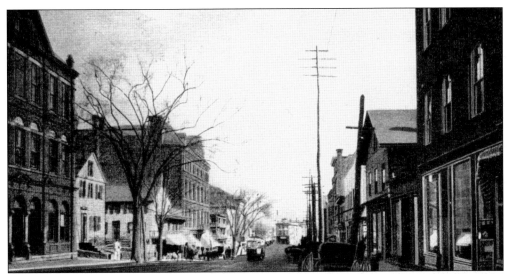

Looking east along Main Street from Walnut Street, this view shows a buggy parked on the right side and the Baltic trolley in the distance, climbing the hill from Lincoln Square. The trolley dates the scene to sometime after 1903, when the Willimantic Traction Company began trolley service. The streetcars ran until 1936.

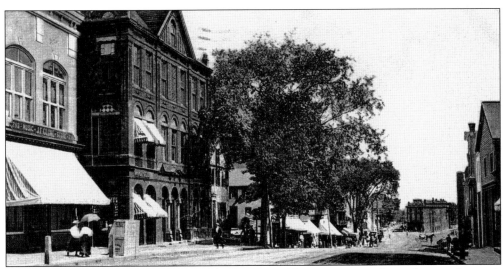

Here is an earlier view of Main Street looking east. There are no tracks evident in the road, and only horse-drawn conveyances can be seen in the distance. It is summer. The trees are in bloom, and shopkeepers have their awnings down. A stroller on the left protects herself from the sun with an umbrella.

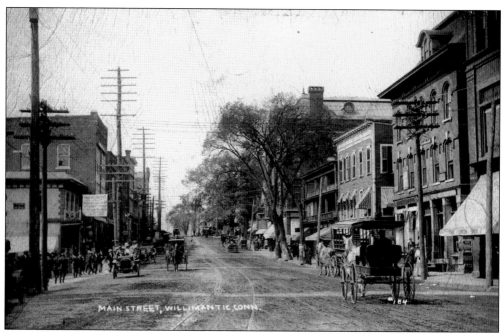

Buggies are still the predominant means of transportation, but they share Main Street with at least one horseless carriage, on the far left. The automobile appears to have attracted the attention of a gaggle of onlookers.

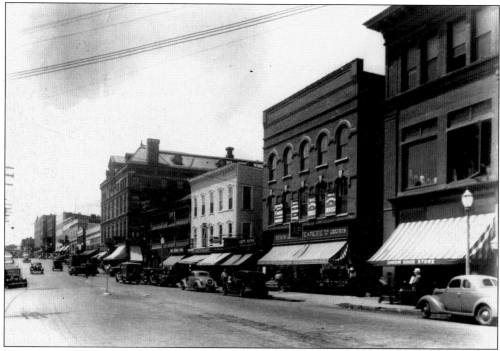

Downtown Willimantic is still the commercial center of the region in 1938. The trolley is gone, and parked cars line Main Street. National and regional firms like A&P, Rexall, and First National Stores have joined local retailers in competing for shoppers' attention and dollars.

Four

PUBLIC EDIFICES

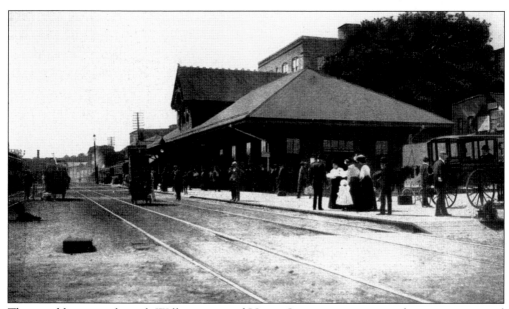

Three rail lines ran through Willimantic, and Union Station was a center of transportation and commerce. At the height of the rail age, 50 trains steamed through town every day. The station was torn down in the 1950s, but the town still has freight service.

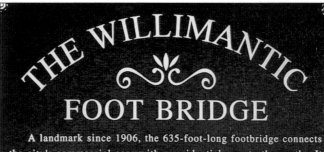

THE WILLIMANTIC FOOT BRIDGE

A landmark since 1906, the 635-foot-long footbridge connects the city's commercial core with a residential area to the south. It is the only such structure east of the Mississippi to span sidewalks, vehicle traffic, an active railroad and a river.

Fabricated in five steel segments by the Owego Bridge Co. in Owego, N.Y., they were shipped to Willimantic by rail and bolted together on site.

This bridge is a necessary and utilitarian link between downtown and residential areas to the south, and is a reflection of a time when the quality of urban life, as measured by such things as better sidewalks and scenic parks, was a major public concern.

The span was designed by Robert E. Mitchell, a local engineer, under contract to the city and was completed at a cost of about $13,000. It is on the National Register of Historic Places.

As the city expanded on both sides of the river, getting from one side to the other was a problem for pedestrians. One observer counted 300 people who used the Central Vermont trestle as a pedestrian crossing in one morning—a dangerous practice. A footbridge was approved, and the Owego Bridge Company of Owego, New York, was given the contract. The company prefabricated the pieces and shipped them to Windham, where they were assembled on site.

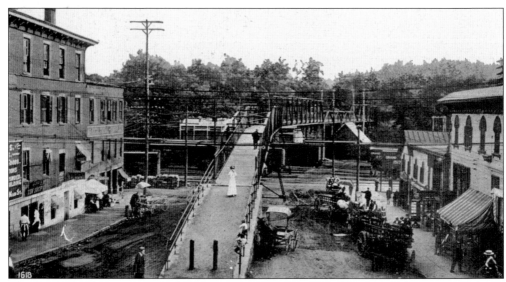

The footbridge became one of the photographed scenes in Willimantic. This postcard shows how the bridge divided Railroad Street at its intersection with Main Street. The rail depot is out of sight around the corner to the right. The bridge crosses Riverside Drive, the rail yard, and the Willimantic River to connect with Pleasant Street on the south side of the river.

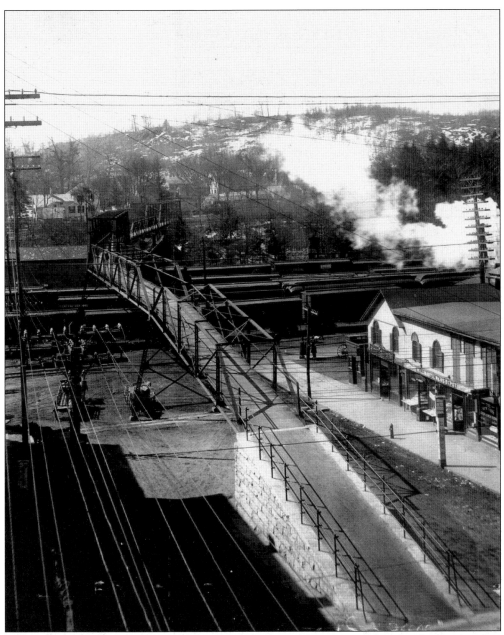

The footbridge was controversial from the start. First, it was a compromise of sorts. A group of businessmen had been agitating for a third highway bridge located between the two stone bridges. They feared that a footbridge would preclude the building of a new road bridge, and they were right. A new highway bridge was not to be built for 90 years. Second, the footbridge job was rushed because of the opposition of the highway bridge proponents. As a result, the engineer's preliminary drawings were used. The stone pier on the north side was not properly positioned, and the steelwork "shoe" of the bridge overhung the masonry pier, raising safety concerns. Despite making it easier for city residents from the south side to walk to downtown, the footbridge was disliked even by the merchants. The Willimantic Board of Trade complained that the money should have been spent on sidewalks instead.

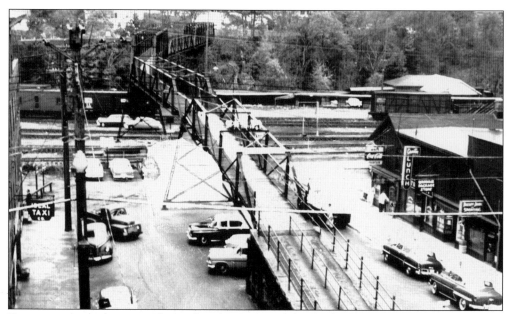

Despite concerns about its safety and its $13,000 cost, the footbridge remains in daily use today. This postcard from the 1950s shows Railroad Street still on both sides of the bridge. The street was eliminated by the 1970s revitalization plan, and the area was regraded. Stairs now connect Main Street to Riverside Drive, which supplies spillover parking for downtown workers and shoppers.

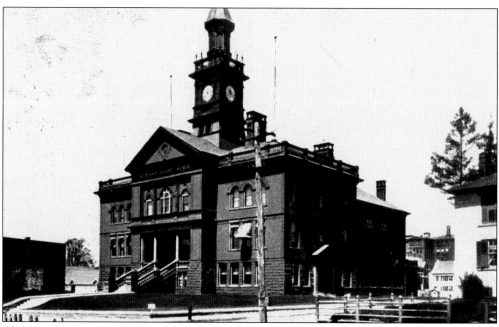

The first public meeting in Windham was held in May 1691. As Willimantic grew, government functions were shifted from Windham Center to Willimantic. The town outgrew its rented space in the Savings Institute building, and this new town hall was occupied in 1896. This photograph was taken between 1896 and 1909, when the house on the right was demolished to make room for the new post office.

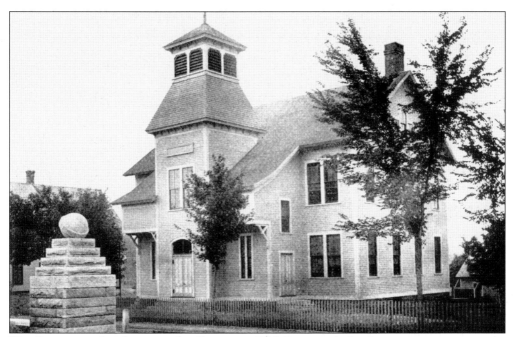

Windham opened its first two schoolhouses in 1713. In an era before buses, towns maintained a number of small district schools to which students could easily walk. The First District School, according to historian Allen B. Lincoln, stood at the western end of Main Street, near the Bridge Street factories.

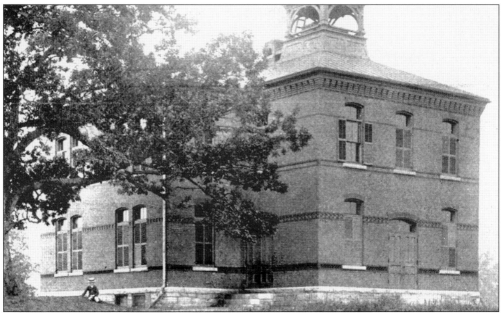

One of the thread company's most interesting managers was William E. Barrows, a compassionate man who used his position to undertake a number of social experiments: free food and drinks for workers during breaks, a library, a dance pavilion, and improved housing in a project called Oakville, or simply, the Oaks. Barrows shocked the aristocracy by building his own house next to the Oaks. Children in the neighborhood attended the Oaks School, above.

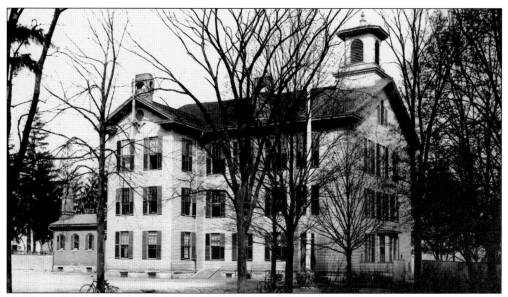

Natchaug School included a high school until 1897. Among its graduates is former Connecticut governor Wilbur Cross. It was a progressive school. Part of the 1883 commencement ceremonies was illuminated by electric light, sponsored by the Willimantic Thread Company. Afterwards, alumni repaired to the Brainard House for a celebration that began at 10:00 p.m. The Natchaug name continues on today as one of the town's elementary schools.

The ambitious missionary Fr. Florimond DeBruycker, who built the town's first Roman Catholic church, also started its first parochial school, St. Joseph School, in 1878. He arrived in town in 1863 to serve the burgeoning population of Irish Catholics, who were working in the city's factories.

The first fire engine company in Willimantic was organized in 1830, according to historian Allen Lincoln. Volunteer fire companies provided not only a valuable service but also a social outlet for their members. Willimantic's Montgomery Engine Company, right, was founded in 1874 and had a dramatic club. This building was located on Jackson Street.

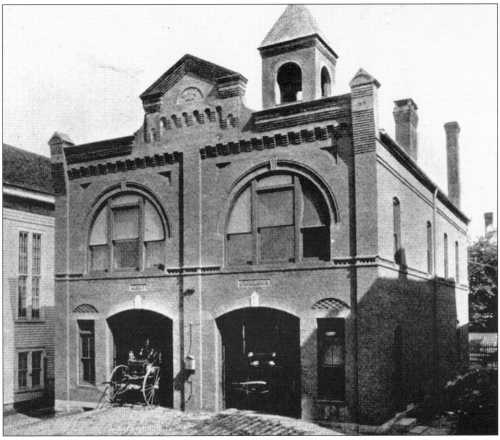

In this 1893 photograph, the Alert Hose Company and the Excelsior Hook and Ladder Company share a station house on Bank Street in Willimantic. A fourth city company, the Hilltop, was formed in 1897. All the companies were combined in 1926 at the Bank Street firehouse, which continued to serve as Willimantic fire headquarters until the present police-safety complex was built in 1977.

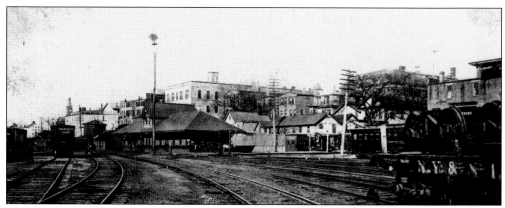

The first railroad came to Willimantic in December 1849, connecting the town with Hartford. A north–south line between New London and Worcester opened the following year. Willimantic's passenger depot was called Union Station and was south of Main Street, about equidistant between the thread company on the east and Windham Manufacturing on the west. At one time, 50 trains per day passed through the city.

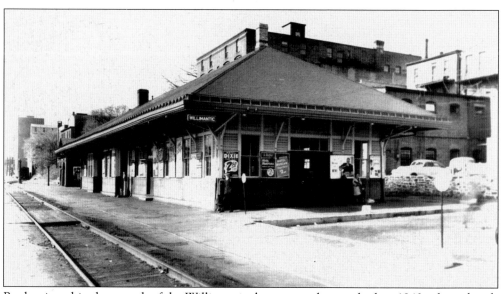

By the time this photograph of the Willimantic depot was taken in the late 1940s, the railroads had passed their heyday. The station that had seen off young soldiers going to fight in the Spanish-American War and two world wars now seems desolate. The missing water tank, seen in the top photograph, is a precursor of what was to happen to the station itself by the late 1950s.

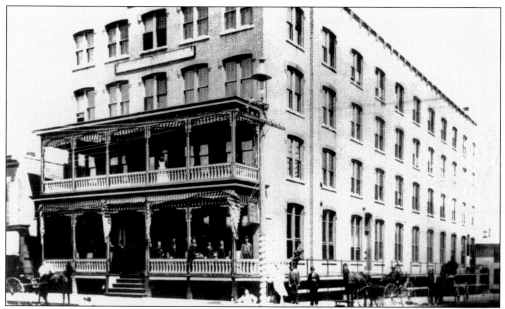

As a busy transfer point and destination itself, Willimantic had a need for proper hotels to accommodate travelers. Seth Hooker bought the old Brainard House in 1882 and worked to improve its reputation. He renovated the rooms and improved the menu. Three years later, he bought a lot at Main and Bank Streets and erected the Hotel Hooker, shown. The new hotel enjoyed central heating, an elevator, and bathrooms on every floor.

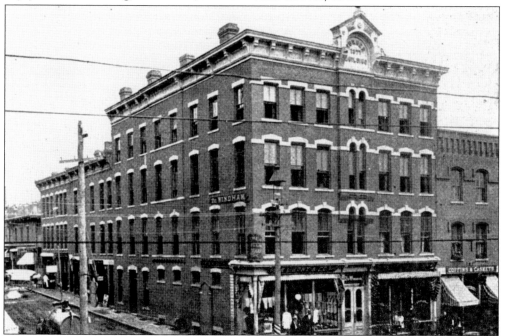

One of the Hotel Hooker's competitors was the Windham Hotel, at Main and Church Streets. Built in 1877, it was later operated by Samuel Clark, a former conductor on the famous New York-to-Boston "White Train," which ran through Willimantic. It offered 50 guest rooms and a billiards parlor in the basement.

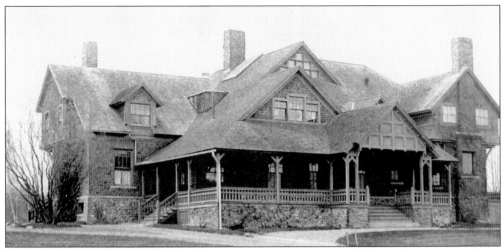

Dr. Louis Irving Mason bought the Fairview Avenue mansion of William E. Barrows and put on a three-story addition to make space for an operating room and patient wards. It was one of three private hospitals in the city in the early years of the 20th century. Mason closed the hospital during his World War I service but reopened it after the war. Another hospital, on North Street, was owned by Dr. Laura Heath Hill.

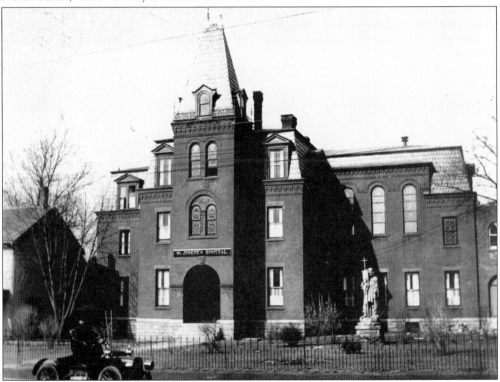

The third hospital was St. Joseph, on Jackson Street. Although operated by the Sisters of Charity, the hospital was nonsectarian and took patients regardless of race or religion. By 1929, it was routinely running at its capacity of 20 and was turning patients away. The donation of 12 acres of land off Windham Street by the Vanderman family and the raising of $500,000 led to the creation of the Windham Community Memorial Hospital.

The Methodist church gave Church Street its name. It was dedicated in 1857. This photograph is from 1862. The Methodists were active in town, founding a camp meeting ground on the other side of the river that drew crowds of up to 5,000 people. The church was demolished as part of the 1970s downtown redevelopment.

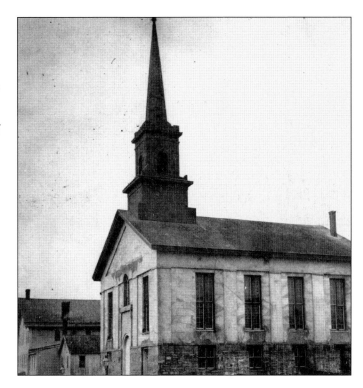

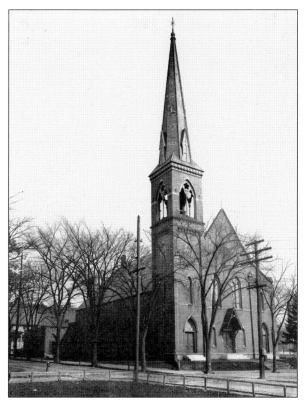

This is the "new" Congregational church in Willimantic. Construction of the 1870 church at the corner of Valley and Walnut Streets was made possible by a donation of land and contributions from the town's leading Congregationalists. The church began on Main Street in 1828.

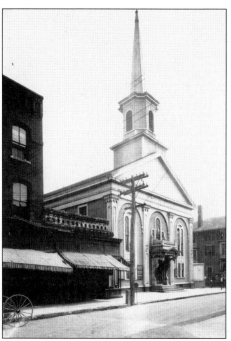

Willimantic's Baptist church, built in 1844, originally had a Union Street address. That changed during road realignment that was part of the 1970s redevelopment. It now has a Main Street address and abuts Jillson Square. The Candy Kitchen store can be seen to the left of the church in this photograph.

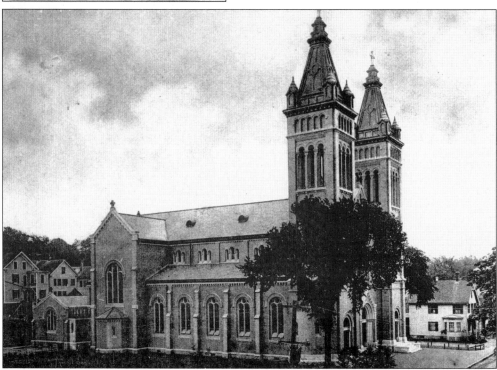

St. Mary Roman Catholic Church is barely two blocks from St. Joseph Church, the church founded by Fr. Florimond DeBruycker. In the second half of the 19th century, the mills needed new labor and began recruiting French Canadians. Recognizing the tensions between the established Irish and the newly arrived French Canadians, DeBruycker left money in his will to help establish a French church.

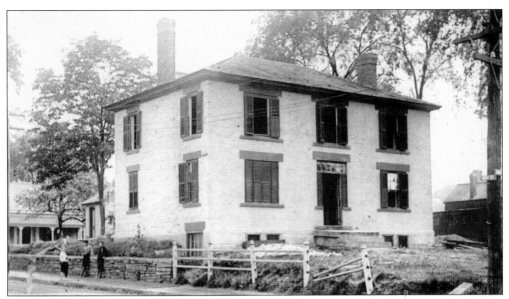

This house on the northeast corner of Main and High Streets was torn down to make way for Willimantic's new post office in August 1909. The property was purchased for $10,064, and $64,488 was allotted to construct the new building.

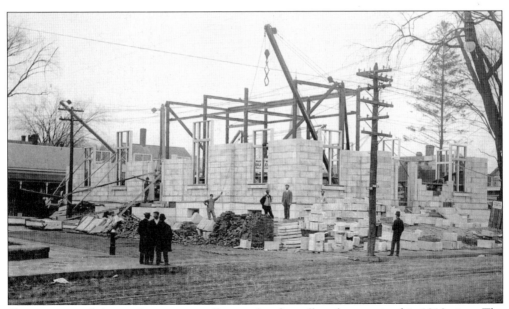

Construction of the city's new post office is already well under way in this 1910 view. The granite-and-limestone building, across High Street from the city hall, was a fitting edifice for a prosperous city and the largest town in Windham County.

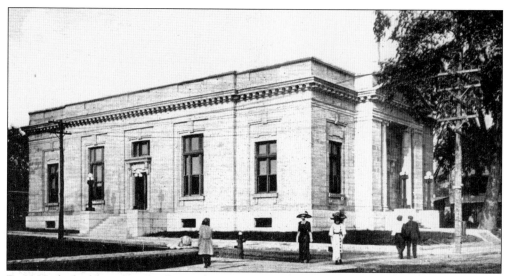

By 1912, the building was complete and operational. It served the city until the current post office building opened in December 1966 just several doors up the street. The magnificent building stood empty for more than 20 years until it was completely renovated by a local entrepreneur. It is now home to a popular restaurant and microbrewery, and features a 12- by 17-foot mural of a 1920s street scene.

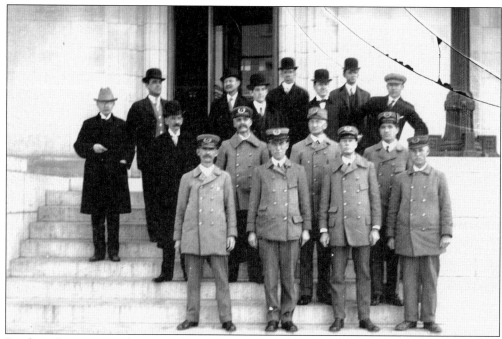

Ready to brave snow, sleet, rain, hail, and protective dogs, the staff of the Willimantic Post Office takes time to pose for this shot in front of the new building. Previously, the post office was located at 676 Main Street.

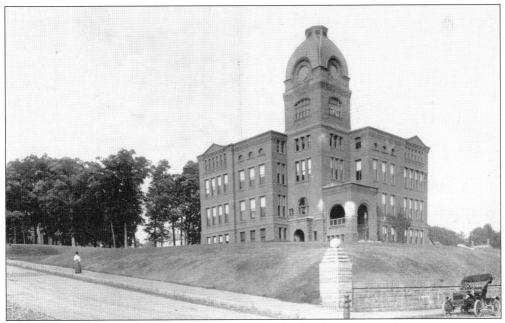

Occupying a high spot on Valley Street, the normal school's distinctive tower could be seen from just about anywhere in the city. It was known as Willimantic Teachers College by the time this building was destroyed by fire in 1943. Despite the setback, the school has prospered over the years. It is now Eastern Connecticut State University.

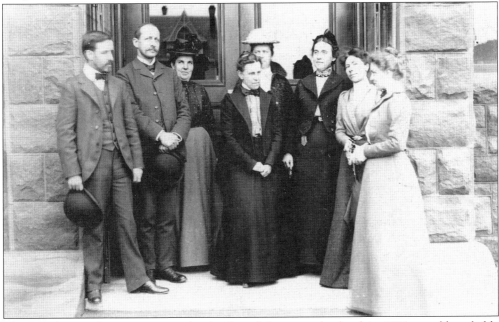

These eight people, representing the faculty of the normal school in 1901, would probably be amazed by the scope of Eastern Connecticut State University. Although the university still maintains a building and a dormitory on Valley Street, it began constructing its new North Campus in the late 1960s. The campus consists of 50 buildings spread over 178 acres. Enrollment is 5,100, and full- and part-time faculty number more than 300.

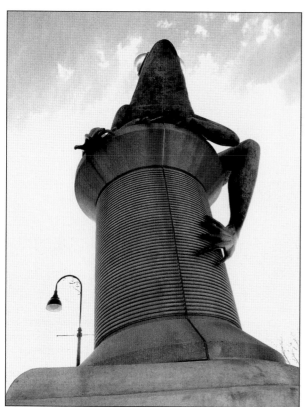

The history of the battle of the frogs is recalled in the Thread City Crossing bridge. Begun in 1999, it was one of the first "architectural" bridges built by the state in years. At each of the bridge's four corners is a huge bronze frog statue mounted on concrete spools of thread, representing the city's significant textile history.

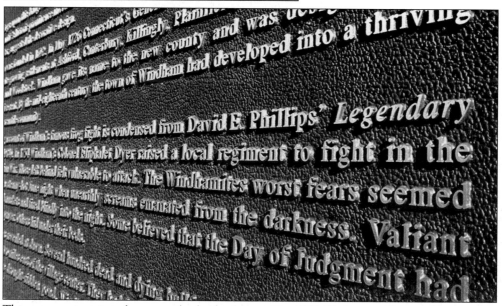

This commemorative plaque on the bridge honors David E. Philips, an Eastern Connecticut State University professor who proposed the symbolic design of the bridge. Philips was a well-known folklorist who sent his students out across the state to conduct interviews. He wrote what is perhaps the definitive book on Connecticut folklore, *Legendary Connecticut*. The unfortunate misspelling of his name on the plaque has been corrected.

Five

DOWNTOWN

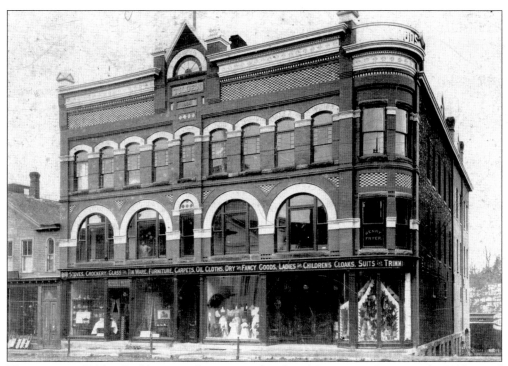

The imposing Tilden Building, on the corner of Railroad Street, was home to the Tilden and Courtney department store. The Jordan family bought the building around 1906 and operated a hardware business there until the building was destroyed in a fire in 1916.

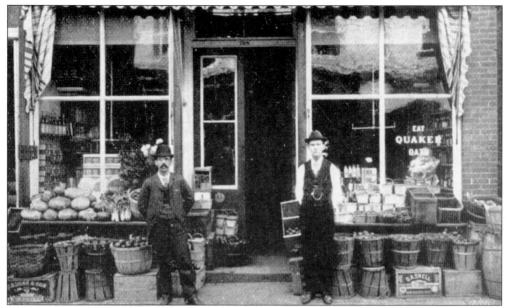

Burt Thompson's grocery was located on the ground floor of one of the city's better known buildings: Franklin Hall, at 798 Main Street. Thompson, on the left in this photograph, bought out the existing grocer in the building after a 10-year apprenticeship at other grocers. Franklin Hall's ballroom, on the top floor, was the scene of many of the city's best parties.

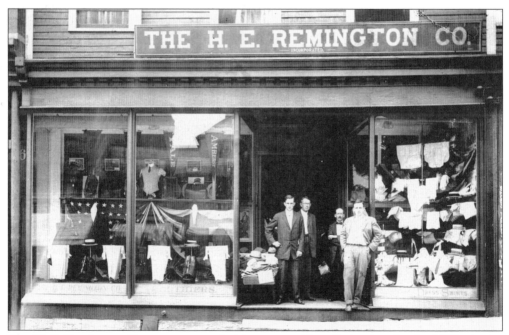

The H. E. Remington Company was a clothing store with a distinction. In the 1880s, it also housed the first "central," or telephone switchboard, in the city. The switchboard required one person to operate it. Some 40 years later, the Southern New England Telephone Company built a two-story brick building behind town hall to house equipment to service the growing number of telephone users.

The Tanner Block occupied the northeast corner of Main and North Streets. It probably took its name from the fact North Street is shown on early maps as Tanners' Lane. Here, the photographer seems to have captured the attention of store owners and passersby alike. The wood-frame structure was typical of many downtown buildings that were replaced by more imposing brick structures near the end of the 19th century.

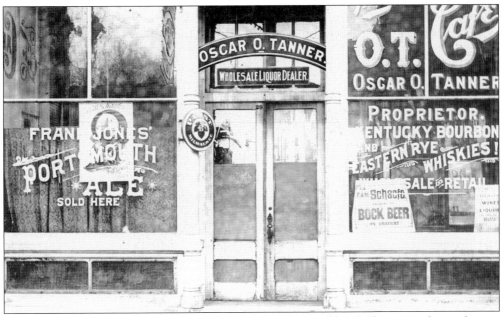

Oscar O. Tanner owned a saloon, managed a local professional baseball team, and was a boxing promoter who claimed to be a personal friend of champion boxer John L. Sullivan. Despite the notoriety of his saloon, Tanner was twice elected city mayor.

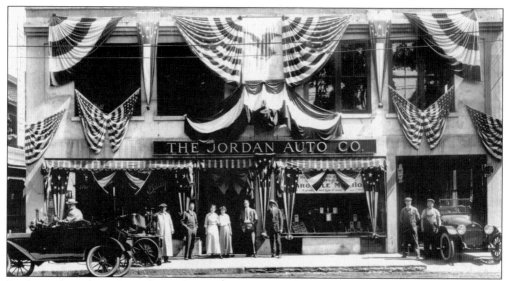

By the early 20th century, a new type of business had sprung up in downtown. The Jordan Auto Company was owned by the same family that owned Jordan Hardware. This store occupied the corner of Main and Windham Streets in the west end where Benny's is now. The Jordans bought the property from another early auto dealer, E. P. Chesbro.

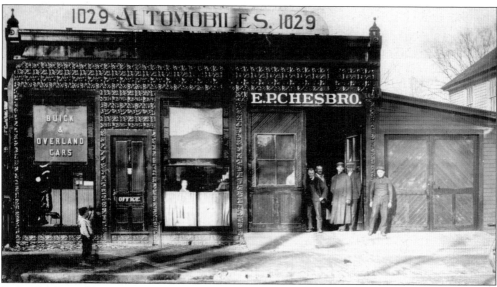

E. P. Chesbro sold carriages, sleighs, bicycles, and insurance in the mid-1890s. It was a natural progression to selling Buicks and Overlands from this location, at 1029 Main Street. Overland began producing cars in Indianapolis in 1907, making 47 of them that year. It eventually became Willys-Overland, remembered today as the manufacturer of a vehicle made famous by World War II: the Jeep.

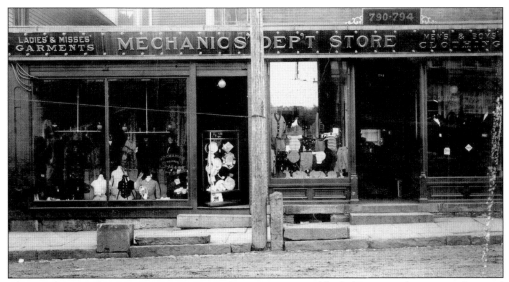

The Mechanics' Store, at 790–794a Main Street, was owned by L. Feiner and was one of several clothing stores downtown. It carried men's, ladies', and children's clothing. What appears to be a man's dress jacket is displayed in the right-hand window. The price: $9 and change.

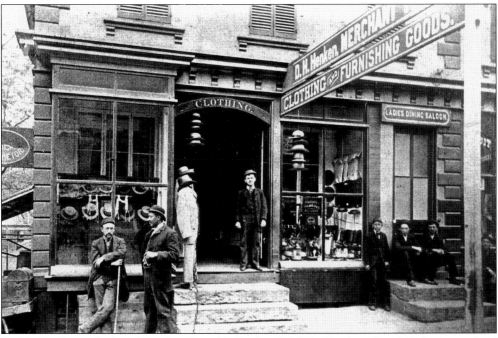

D. H. Henken advertised in the *Chronicle* in April 1880 that he offered "a large stock of clothing and gents' furnishing goods of all styles. . . . The stock is all new and worth looking at." Furnishing goods, what we now call accessories, included collars, neckties, and tiepins. The store was located on the first floor of the European Hotel.

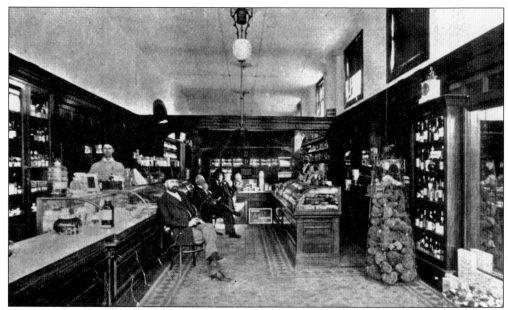

Samuel Chesbro was an experienced druggist when he opened his pharmacy in the Loomer Opera House. A contemporary report described it this way: "The tile floor is of ornate pattern [and] the wainscoting and counters are of quartered sycamore." Chesbro kept his laboratory in the back and in the basement. There, he made Clover Compound, a tonic that "purified" the blood and was an "all-around regulator."

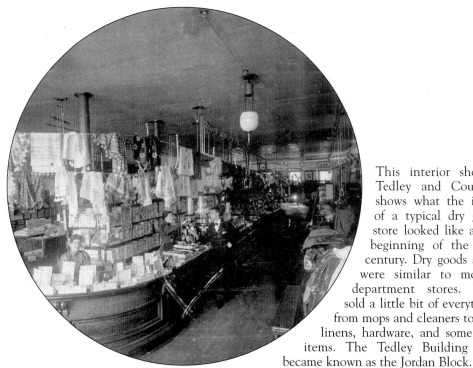

This interior shot of Tedley and Courtney shows what the inside of a typical dry goods store looked like at the beginning of the 20th century. Dry goods stores were similar to modern department stores. They sold a little bit of everything, from mops and cleaners to bath linens, hardware, and some food items. The Tedley Building later became known as the Jordan Block.

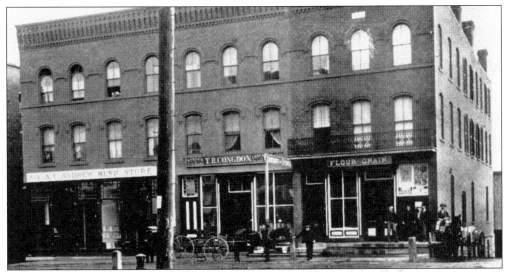

The Chapman Block occupied a prominent position at the crest of Main Street. In this view, it houses the A. C. Andrews music store and a grain dealer. It was damaged by fire in the early 1990s. By 2004, water had caused structural damage, and the town tore it down over the objections of preservationists.

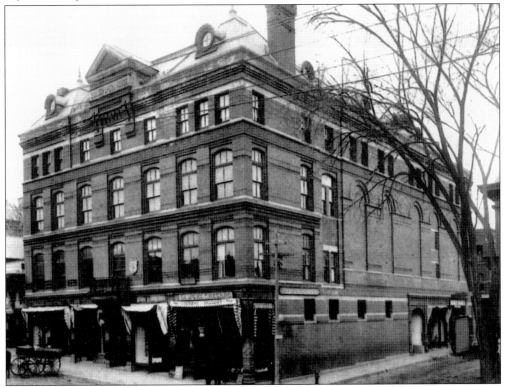

The sturdy Loomer Opera House, with its distinctive roofline, was built by Silas F. Loomer, a local lumber, coal, and insurance man. There were stores on the first floor, offices on part of the second, and society halls on the top floor, but the bulk of the building was used for a 1,100-seat opera house. Buffalo Bill Cody, Charlie Chaplin, and Stan Laurel all appeared there.

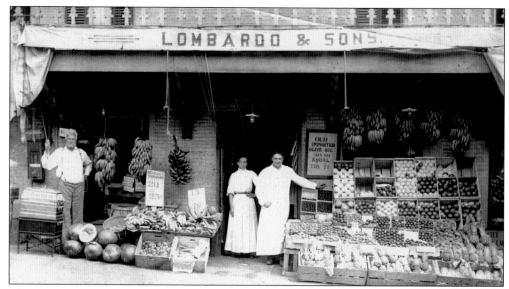

The Lombardo and Sons grocery attracted customers with its display of fresh produce along the sidewalk. The man on the left stands behind a peanut roaster, and the sign next to the door promises "our imported olive oil has no equal." While the predominant populations of 19th-century Willimantic were Yankee, Irish, and French Canadian, other ethnic groups, including Ukrainians, Syrians, and Italians, found a home here.

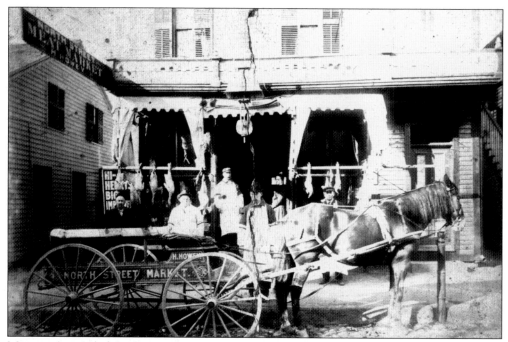

Many stores, including the North Street Meat Market, offered delivery. Small food stores like Lombardo's and Larrabee's on Church Street served the local community well, offering an array of products and services like delivery. They proved that small shops could compete against much better-financed businesses such as William E. Barrows's company store.

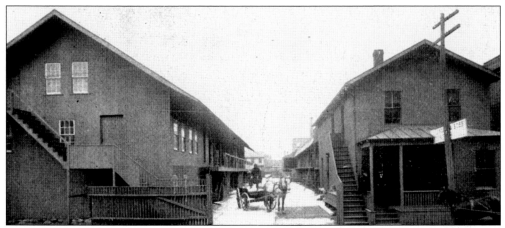

Lincoln & Boss maintained this lumberyard at North and Meadow Streets in addition to a smaller lumberyard and a coal yard near the railroad depot. The combined yards could hold 750,000 feet of lumber and 1 million shingles. The coal yard had a capacity of 2,000 tons.

Main and Union Streets was one of the city's most important intersections for 100 years. Lincoln's furniture store occupied the split between the two streets. The building was known locally as the Flat Iron Building, even though it was neither flat nor of iron construction like its namesake building in New York. The Baptist church can be seen on the left on Union Street.

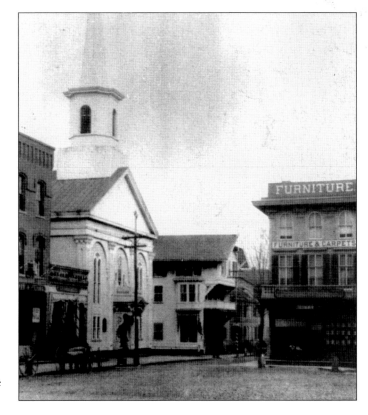

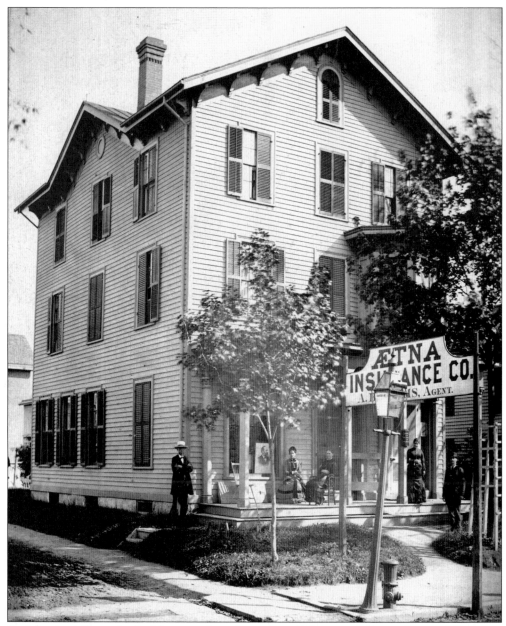

Built by Asa Jillson, this building stood on the corner of Union and Center Streets. Jillson was in the insurance business, and the building housed a succession of insurance agents, including the company that became the modern Sumner and Sumner. The poster of Pres. Chester Arthur in the window would likely date the photograph to sometime between 1881 and 1885.

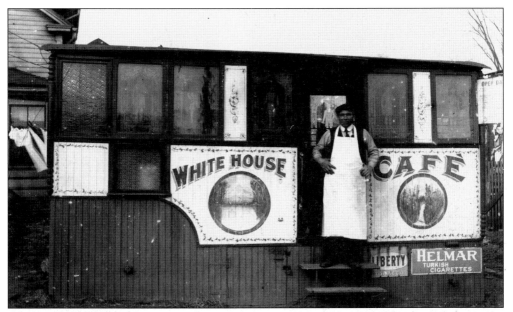

Lunch wagons, predecessors of the modern diner, served shift workers at the factories. The White House Cafes were made by T. H. Buckley Company in Worcester, Massachusetts, from 1888 to about 1901. Many operators, like the one in this picture, put the lunch wagons on semipermanent foundations. Operators of the period included Jacob C. Lakin, who advertised his "night lunch wagon" at Lincoln Square in the 1893 city directory.

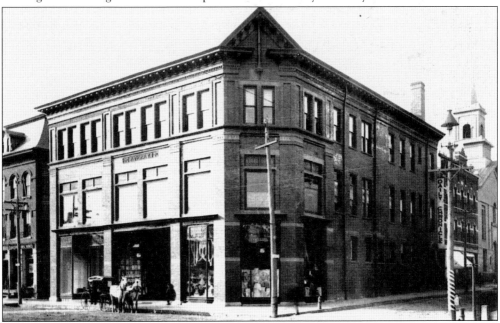

In 1892, Hugh G. Murray erected this landmark building, known to generations as Murray's Boston Store and considered the finest department store in the city. Modern residents remember it as the home of the Hurley's clothing store, which operated until recently. Behind it were the *Chronicle* offices and the Methodist church. Both buildings are gone now, and the land is a parking lot.

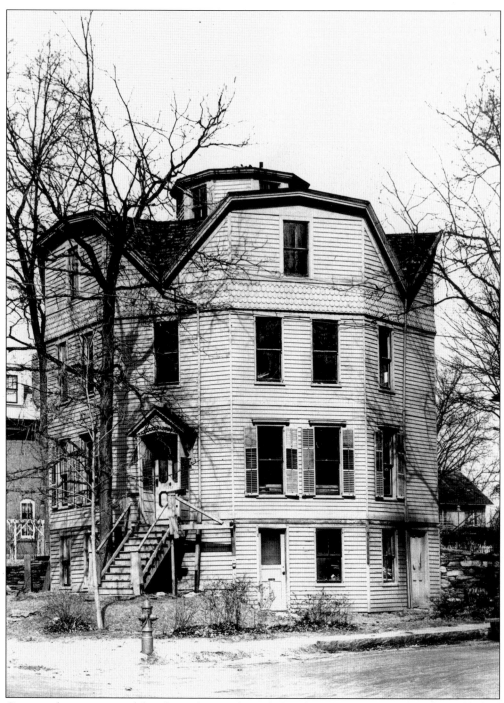

Octagon houses enjoyed brief popularity after 1848, when Orson Squire Fowler published *A Home for All*, which promoted eight-sided homes as cheaper and healthier. This one, at Summit and Walnut Streets in Willimantic, was built by Charles Beckwith. An undated penciled notation on the back of the photograph states that the owner is a woman of nearly 100 years of age who "likes pears." The house was demolished in the 1930s.

Six

LIFE IN A SMALL CITY

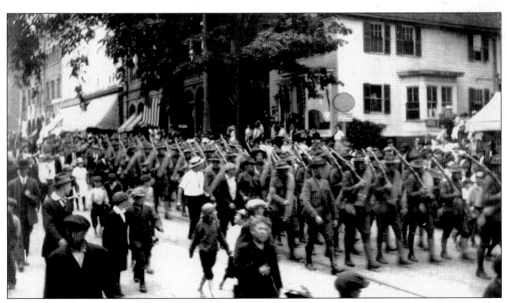

Willimantic's Company L of the Connecticut National Guard marches to Union Station after the unit was called up during the Mexican border dispute of 1916. National Guard troops from many states were nationalized after a raid blamed on Mexican rebel Pancho Villa killed Americans in New Mexico.

Where you lived and the style of house you lived in varied considerably depending on your economic status. Most mill operatives lived in company-owned housing. These single-family homes in the Oaks neighborhood were nicer than most. Low wages limited housing options, but so did the fact that some factories paid part of their wages "in kind" rather than in cash, providing necessary items like potatoes for meals or wood for heating.

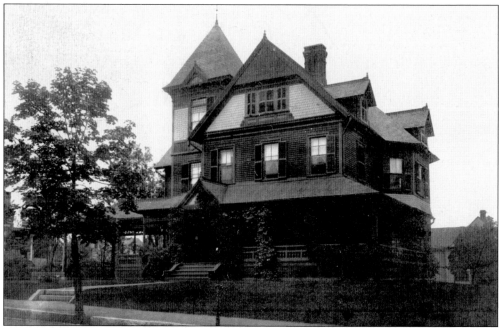

At the other extreme of housing options—and the other end of town—were mansions like this one owned by Joseph Chaffee, a local silk manufacturer. Chaffee built the house in 1889 at the corner of Summit and North Streets. The heating system for the house cost $3,000. At the same time, Chaffee's competitor, the Turner silk firm, was advertising for mill hands at a salary of $6 per week.

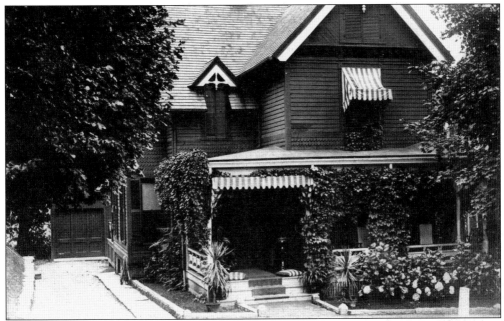

This slightly more modest house, at 215 Church Street, was home to five generations of the Bartlett family, publishers of the local daily newspaper, the *Chronicle*. The newspaper's offices were down the hill, an easy walk if the publisher wanted to go home for lunch. The house has been sold, but the newspaper, founded in 1877, continues to be operated by the same family.

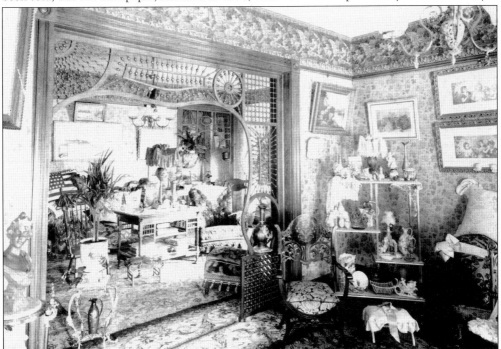

Not just the imposing exteriors spoke to the success and standing in the community of the owner. This ornate parlor, with its woodwork, wallpaper, and the bust on the corner table, made it clear the owner was part of the city's upper middle class.

The *c.* 1825 stone house of William Jillson was built of the same local gneiss granite used in several of Willimantic's cotton mills. The Jillsons were among the textile pioneers of Windham, manufacturing both cloth and an improved carding machine. By the early 1970s, however, the once impressive house on Union Street had fallen into disrepair. Only its placement on the National Register of Historic Places saved it from the wrecking ball.

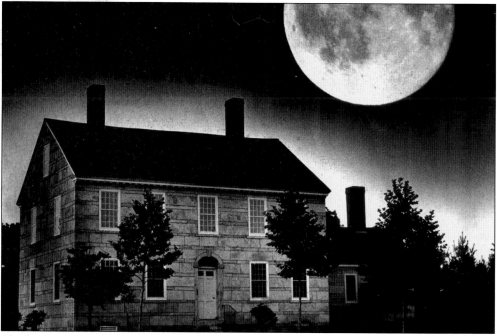

The house is shown here after restoration. It sits on the Jillson parcel, a large green left when redevelopment plans fell through. Residents voted recently to keep the site as open space. The house is now the home of the Windham Historical Society and provides room for the society's library and exhibitions.

Textile entrepreneurs and their investors often owned more than one mill. Thus, they relied heavily on the mill agent, who represented and had the full authority of the absentee owner. The mill agent's compensation equaled his responsibility. This reproduction of a parlor in a mill agent's house is displayed at Willimantic's Mill Museum. It is a spacious room with a paneled ceiling, deep, airy windows, and a fancy rug on the floor.

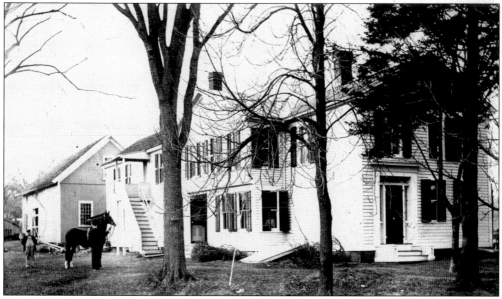

This house is identified as that of Harry Potter. It was located in the fork of the present Routes 66 and 32. The Willimantic Cemetery is located on land that originally was part of the Potter farm. One can find numerous references to Potters throughout Willimantic history. Family members included builders and merchants. One of the city's present-day funeral homes is operated by Potters.

There are no markings on this photograph to identify the workers, the kind of work they are doing, or the project they are working on. The rounded brick structure immediately behind the workers might be a smokestack for one of the mills. The white toes of the boots worn by what appears to be the foreman suggest cement dust.

This photograph, too, fails to identify the workers or what they are doing. What appears to be railroad tracks lie in the foreground, and a steam engine is obvious, as is what seems to be a cement mixer. The photograph may have been taken during the construction of Mill No. 4. It is known temporary tracks were laid to bring in building materials and a 10-horsepower steam engine was used to drive a wood lathe.

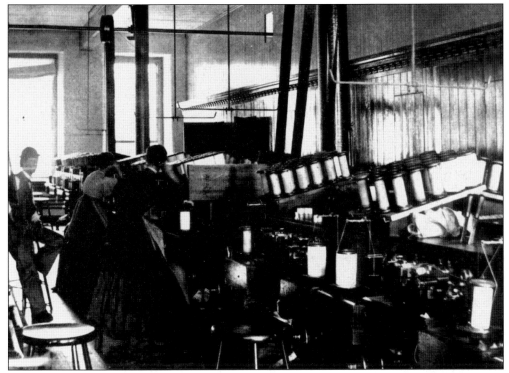

Workers tend winders at the thread company in this early scene. Mill work fed and housed thousands of families, but it was dirty, hard, and stressful. Overseers kept a close eye on production, and slackers and those with sharp tongues were given the same treatment: dismissal. Note that the operatives are women and the overseer is a man.

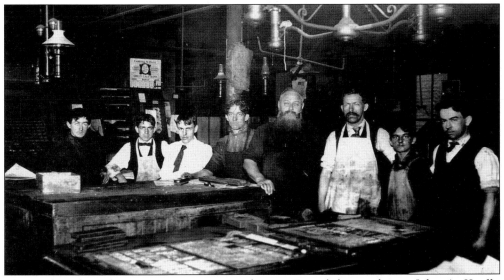

This is the *Chronicle* composing room around 1899. From left to right are John A. Keeffe, Majoric Lord, George A. Bartlett (who later became publisher), Oscar Redman, Fayette Stafford (one of the newspaper's founders), Elmer Young, Alfred Noel, and John Duggan. Metal type is set into chases, seen in the foreground, ready to be made into printing plates.

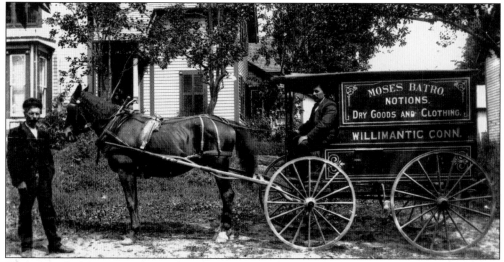

In the age before automobiles, delivery was an essential service. In addition, many vendors traveled door-to-door peddling their wares.

This is the barbershop of Adelard Monast in the basement of the Hooker Hotel about 1910. Many men went to the barber daily for a shave. In the mirror can be seen the personal mugs of shaving cream kept on hand for regular customers.

Eugene Hickey, a local undertaker, stands by a hearse. The man next to the horses is identified as James Jones. In the wagon's window is a sign bearing the name Smith. The photograph was taken in front of C. M. Jordan's livery and feed store.

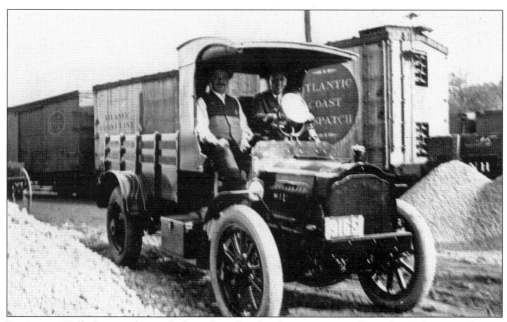

Benjamin Hill drives what is believed to be the first commercial truck in the area. It was purchased by Foley & Henry, a local trucking firm. John J. Foley is in the passenger seat. His partner was Thomas P. Henry. When the Packard truck arrived, it was put on display in front of the company's Railroad Street offices for several days.

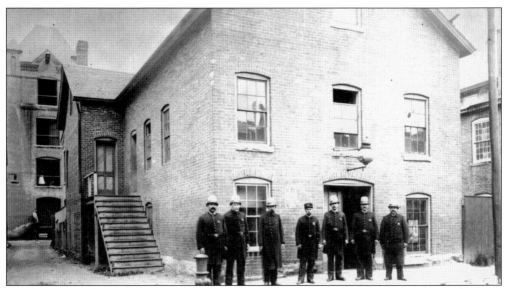

The first constables in Windham were appointed in 1746. In 1881, Willimantic hired three officers to patrol the streets at night and deputized the thread company's watchman as a special constable. This photograph of the city's police force in 1890 was taken in front of the old town hall on Church Street. In 1892, police chief William Newell was charged with assault and frequenting a house of ill repute. He was replaced shortly thereafter.

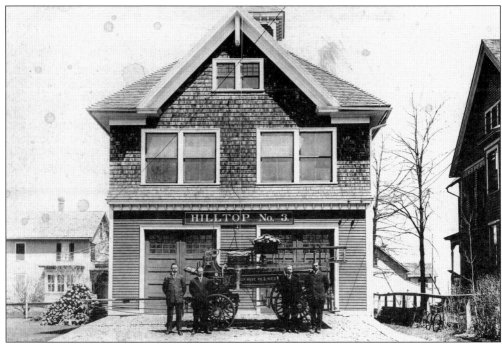

The Hilltop Company in Willimantic boasted a two-bay garage. Because the companies served a social function as well as a civic one, most had club rooms upstairs—some quite elaborate—which provided room for cards, a game of billiards, or conversation and a smoke.

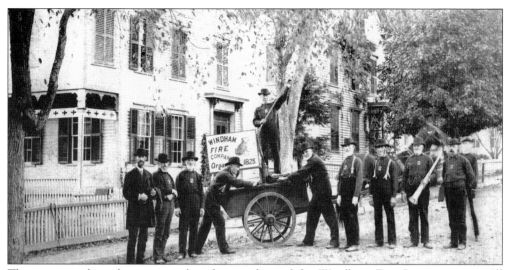

They may not have been young, but the members of the Windham Fire Company were still ready to spring to action when this photograph was taken. The company bought the first fire engine in Windham County in June 1825. The cost was $180. The company had monthly drills and practices. Those absent or tardy were fined, but the money was put to good use: an annual supper at one of the local hotels.

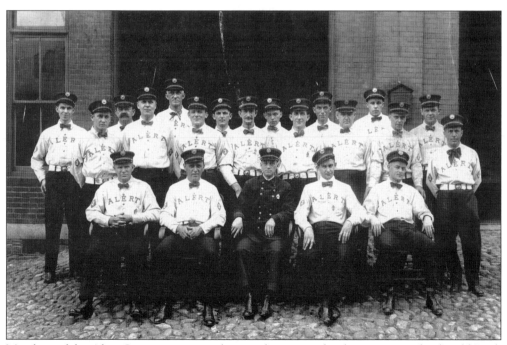

Members of the Alert Company pose in their uniforms outside what appears to be the old Bank Street firehouse. Membership included merchants and other business owners.

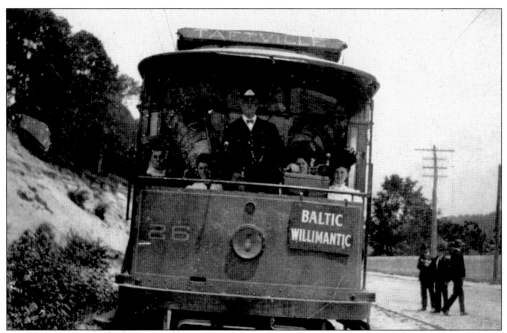

The opening of the trolley line in 1903 by the Willimantic Traction Company made it easier to get to Norwich, 30 miles south. The trolley went as far as Baltic, where passengers had to transfer. Shortly afterwards, a line from Willimantic to Coventry was added. Passengers who wanted to travel the full distance from Norwich to Coventry had to make a second transfer in Willimantic.

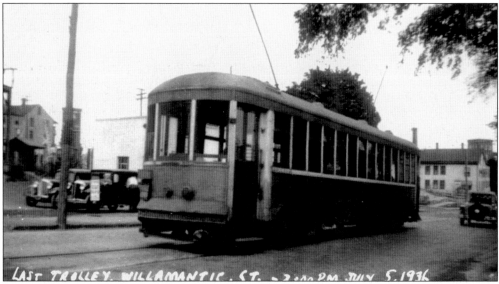

The trolley lasted barely a generation. The last trolley left Willimantic at 2:00 p.m. on July 5, 1936. The Willimantic Traction Company was sold to Consolidated Railway in 1905, eventually becoming part of the Connecticut Company, which switched to buses in 1936. Connecticut Company, part of the New York, New Haven and Hartford Railroad until 1964, was sold to a Hartford businessman and operated privately until 1976, when it became part of the state-owned Connecticut Transit.

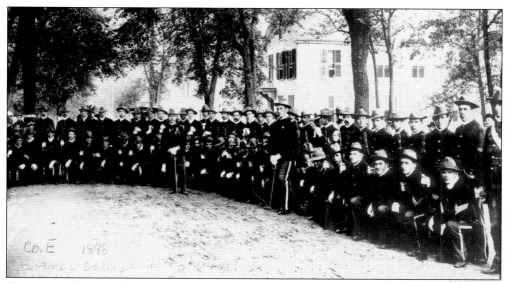

Company E lines up for a group shot at the corner of Valley and High Streets in May 1898 before shipping out to serve in the Spanish-American War. Company E was part of the 3rd Regiment, Connecticut Infantry. Willimantic had a personal interest in the war. A local sailor, James Shea, was a coal passer on the *Maine* when it was sunk in Havana Harbor in February 1898. He died.

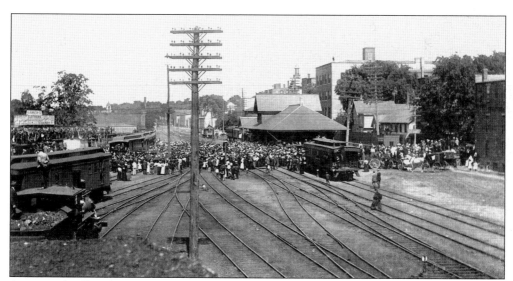

A group of well-wishers crowds around Union Station to bid farewell to the men of Company E. Luckily, Company E did not see any action during the short-lived war, passing most of the time in army camps in the American South.

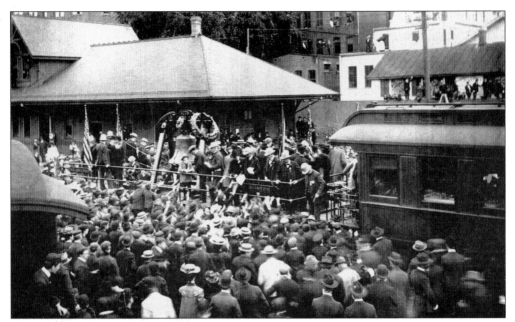

A crowd gathered again at the railroad depot on June 16, 1903, to get a peek at the Liberty Bell. Between 1885 and 1915, the historic bell traveled seven times to various exhibitions, making some 400 stops along the routes. When a train took the bell to Boston in 1903 for the 128th anniversary of the Battle of Bunker Hill, Willimantic was one of the stops.

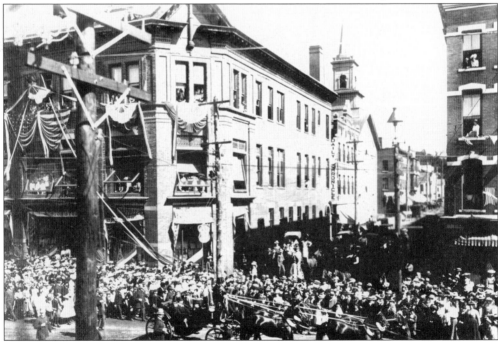

Theodore Roosevelt visited town on August 23, 1902. He arrived by train and then rode by carriage in a short parade from Willimantic's Union Station past the corner of Main and Church Streets to Lincoln Square, where he addressed an enthusiastic audience. He is one of three presidents who came here. Ulysses Grant visited in 1880; William Howard Taft, in 1915.

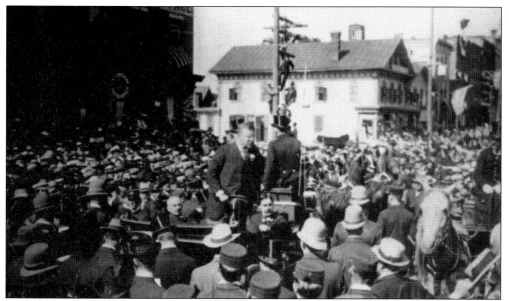

A hatless Theodore Roosevelt was greeted with cheers of "Bully for Teddy" when he stood to speak. In the background can be seen some young men who have climbed a utility pole to get a better view of the president and hero of San Juan Hill.

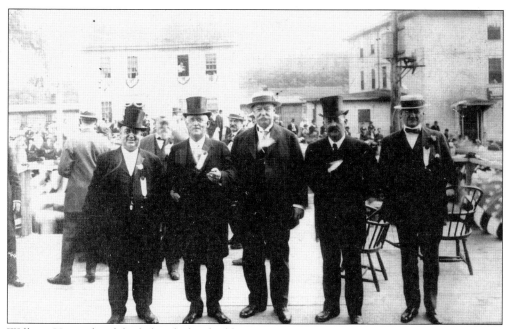

William Howard Taft had already finished his one term in office when he visited town on June 24, 1915, as part of Windham's Old Home and School Week festivities. Taft, sporting a boater, poses third from left with the event's organizers on the lawn of the town hall. Old Home and School Week had its origins in a 1905 reunion of Natchaug graduates.

These are the grounds of the Willimantic Camp Meeting Association, which purchased the land in 1860. A boardinghouse, private cottages, and tenting areas accommodated thousands who attended annual religious revivals each summer. Historian Ellen D. Larned said the 30-acre camp could handle crowds of up to 5,000. The cottages, with their gingerbread trim, are still used.

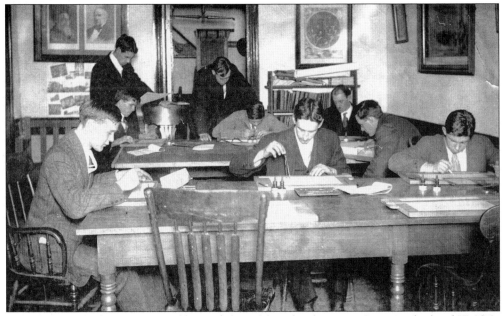

Opportunities for learning existed beyond the public school system. One was the local YMCA. Here young scholars appear to be learning drafting skills. The gymnasium of the original YMCA, at 136 Valley Street, was used by the basketball team of the Willimantic Trade School, located nearby in the old Turner Silk Mill. Students at the trade school attended school 44 hours a week and received a two-week vacation each summer.

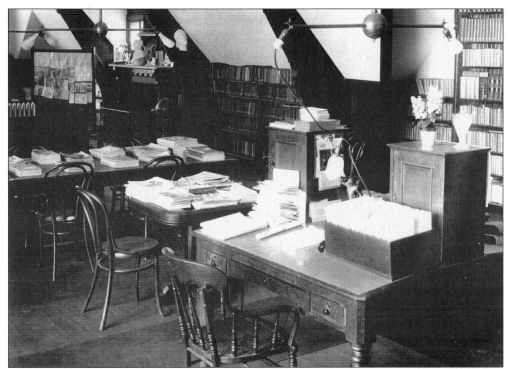

This is the interior of the Dunham Library, one of William E. Barrows's social experiments. Opened in 1879, the library remained open until 1941. Its collection included more than 7,000 books, and it subscribed to 25 newspapers and magazines. Barrows was criticized for his 1882 requirement that all mill hands learn to read and write English. Critics saw a plot to get rid of troublemakers, but the free classes attracted hundreds of appreciative operatives.

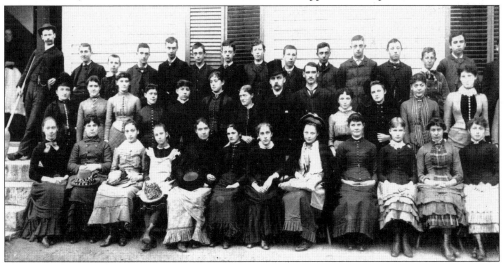

This is the Natchaug class of 1885. The three-story wood-frame building stood from 1865 to 1914 and housed one of two high schools in town, the other being located at the First District School. After Natchaug's first principal left after only a year, the town hired David P. Corbin, who had operated a private select high school in town. The two schools merged into Windham High, which graduated its first class in 1889.

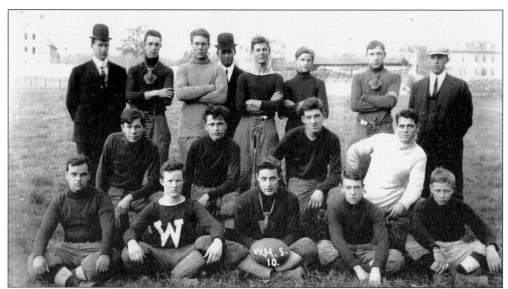

The 1910 Windham High football team appears ready for anything. Historian Allen B. Lincoln wrote that Windham first had a high school football team in 1894.

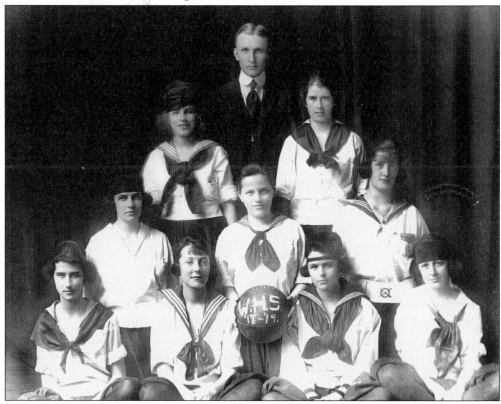

Basketball was less than 30 years old when these girls played on Windham High's team during the 1918–1919 season. Opponents in the early years included the women's team from Connecticut Agricultural College, now the University of Connecticut. In 1903, the college girls won both games of the two-game series.

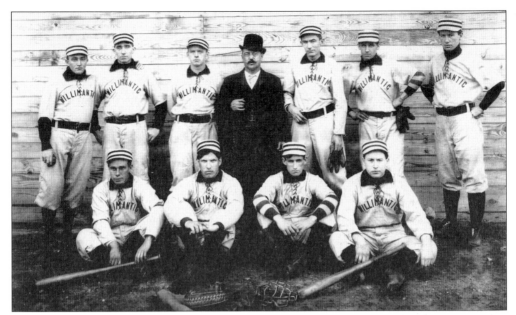

Baseball in all its many variations has always been popular in Windham. This team is not identified, but it could possibly be the Willimantic Colts. Willimantic politician Danny Dunn coached the amateur Colts in the 1890s. The Colts turned professional in 1901 and moved their games from Recreation Park to Windham Field, a new stadium built where Memorial Park stands today. Dunn coached until 1905, the year he was elected mayor.

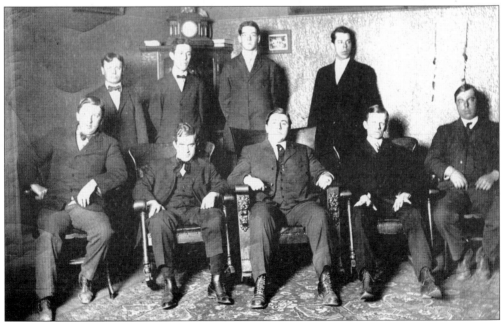

Another popular sport in the late 1800s was cycling. The Thread City Cyclers Club, pictured here, began in the 1890s and continued for 20 years. Cyclists were an important part of the good road movement, an effort that eventually proved a boon more to motorists than to cyclists.

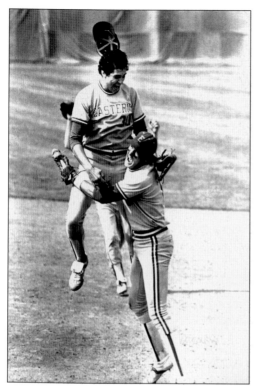

Baseball continues to be a popular sport in Windham today, with children's, adult, and college summer leagues all active. Eastern Connecticut State University baseball coach Bill Holowaty has brought the school national recognition. He is the only Division III coach to win four national titles, and he was elected to the American Baseball Coaches Hall of Fame in 2002. Here, Rob Roveto jumps into the arms of Archie Drobiak after the team won the national title in 1982.

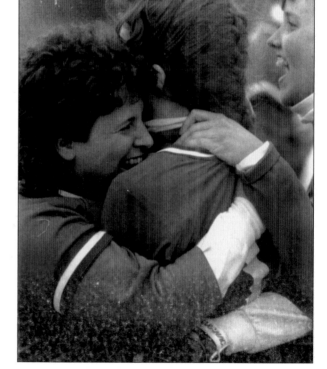

The women's softball team at Eastern Connecticut State University has had its share of success. Here, Denise Lamontagne celebrates with her teammates ~turing the women's 1990. The team players on the ɔnference team.

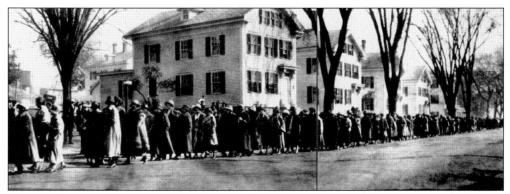

The 1925 strike by American Thread Company workers was one of the most traumatic events in the town's history. Some 3,000 workers walked out in March after the company announced a 10 percent wage cut. Both sides were confident, and both expected a short strike. Both were wrong. The mill brought in workers from the outside and ousted striking employees from company housing. The strike lasted nine months.

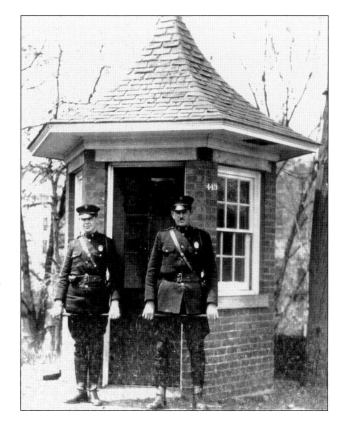

The company brought in state troopers and housed them at the Elms boardinghouse. Here, two troopers stand guard near a factory entrance. The strike caused a rift between the state and city police. The city police thought the troopers were too hard on the strikers.

In the days before air-conditioning, an outing at the park brought shade, a cool breeze, and a reprieve from the noise and congestion of the city. A popular picnic spot was Spring Park, with its clear running spring water, on the outskirts of Willimantic.

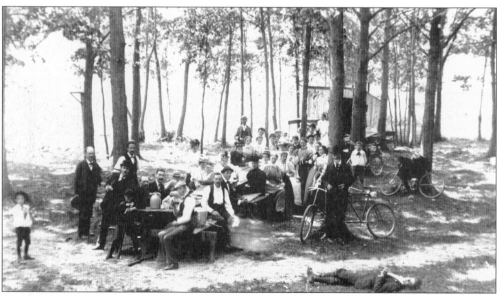

An outing did not mean casual dress. When the Current Topic Club went to Coventry Lake in 1896, most of the men wore vests or jackets, and many sported neckties. The women wore full-length dresses with long sleeves. Even the tyke on the left wears a white shirt with his knickers and a hat. Perhaps the formal wear combined with the high temperature to cause heat prostration in the man lying on the grass.

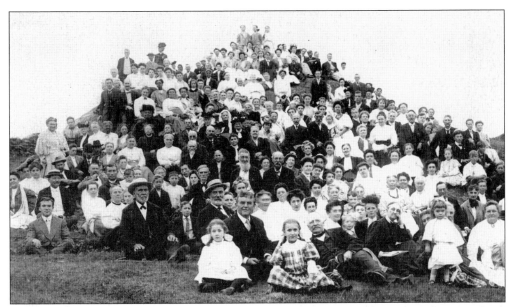

This undated photograph is inscribed, "Service at Sunset Rock, Willimantic, Ct." Sunset Rock was a rise at the Willimantic Campgrounds that provided a natural auditorium for preachers and their listeners. It is clear from this photograph that attendance at the campgrounds was a family affair.

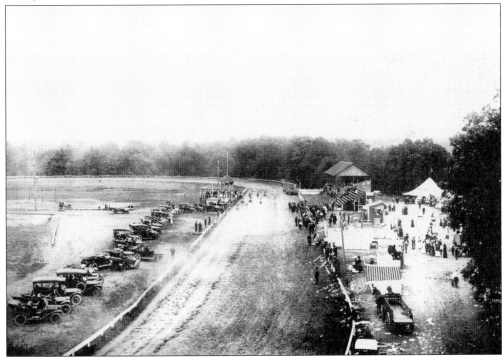

Those more interested in worldly pursuits than eternal salvation found entertainment at the racetrack at the fairgrounds. For years, the fairgrounds was the site of an annual agricultural fair, but its most popular feature was its horse track. The track is long gone, and the fairgrounds are now known as Recreation Park.

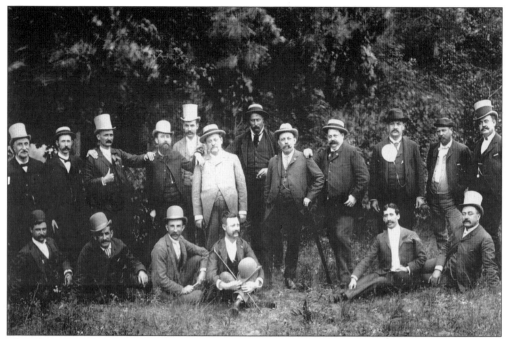

The day was July 12, 1888, when these dapper gentlemen on an outing got together and posed for a proper photograph. The back of the photograph is inscribed with the date and the word "before."

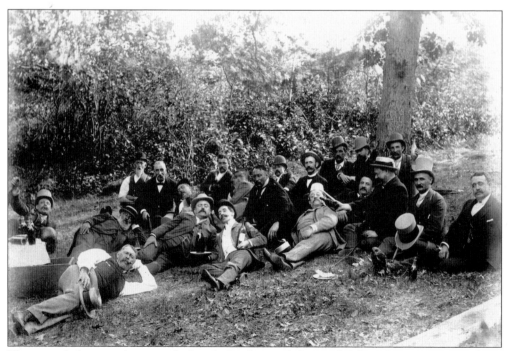

The second photograph is inscribed with the date and the word "after." Propriety is tossed out the window as the effect of some liquid libations has taken hold. A century after these good-natured gentlemen poked a little fun at themselves, their image still evokes a smile.

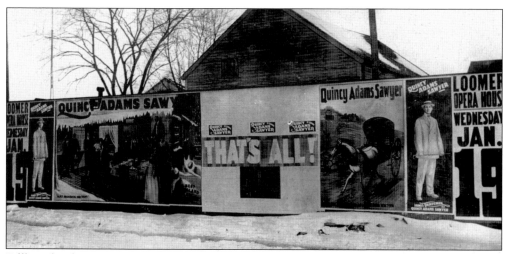

Billboards advertise a presentation of *Quincy Adams Sawyer* at the Loomer Opera House. This was apparently a stage version of a popular novel that was made into a 1922 movie. The movie starred John Bowers, but the poster advertises James Thatcher in the lead role. Thatcher was a vaudevillian. In its declining years, the Loomer did show movies for a while but could not compete with the new Gem or Capitol theaters.

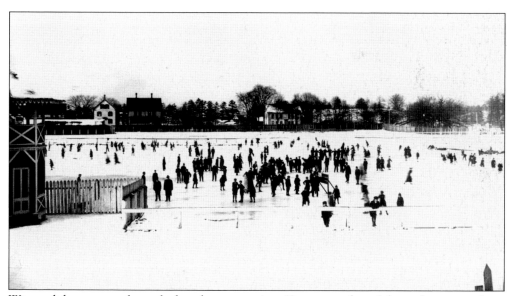

Winter did not mean the end of outdoor recreation. Here, a number of skaters have turned out to take advantage of the cold weather. The setting appears to be the old fairgrounds, another of William E. Barrows's social experiments. Barrows thought that the town deserved a fair to compete with the annual fair in Brooklyn.

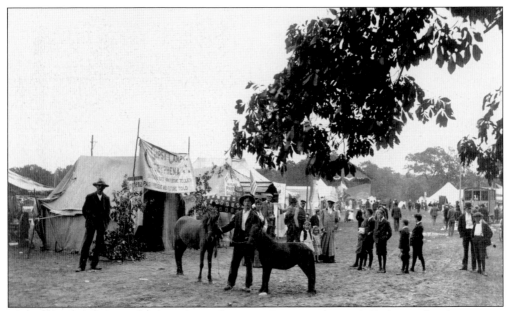

This is a view of the midway at the Willimantic Fairgrounds in 1917. A couple of miniature ponies seem to be attracting more attention than the "Gipsy Camp" fortune-teller. The main attraction throughout most of the fairgrounds history was harness racing. The thread company later donated the land to the town for use as a park.

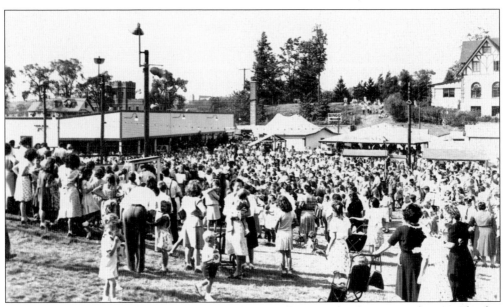

The Elks Club sponsored a fair on Labor Day weekend for nearly 40 years until 1952. The fair on Pleasant Street featured a midway, rides, a fireworks show, and plenty of unhealthy but tasty fair food. You could take a chance by buying a raffle ticket to win a car or play bingo, and at night there was dancing to big band music.

By around 1910, the YMCA was outgrowing its Valley Street facility. When it came time for a new building for the YMCA, the goal was to raise $30,000. A countdown clock mounted on the Lincoln Furniture building kept track of the progress of the drive. The clock's face urged Willimantic residents to "keep time with other cities." By 1914, the YMCA was in new quarters at 844 Main Street.

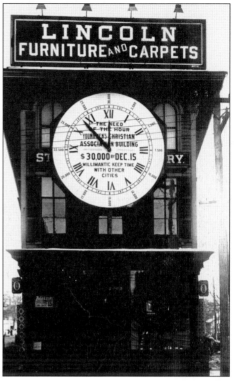

This couple poses for a portrait in Central Village, about 20 miles east of Windham. The clothing is a good example of formal dress at the beginning of the 20th century, and the woman's dress is now in the collection of the Mill Museum in Willimantic.

The Connecticut Elks chose Willimantic's 1927 mansionlike lodge on Pleasant Street for the seventh statewide convention in June 1938. Many a wedding party or chamber of commerce function has been held at the Elks home over the years, and the club, founded in 1914, continues to be a presence in the city.

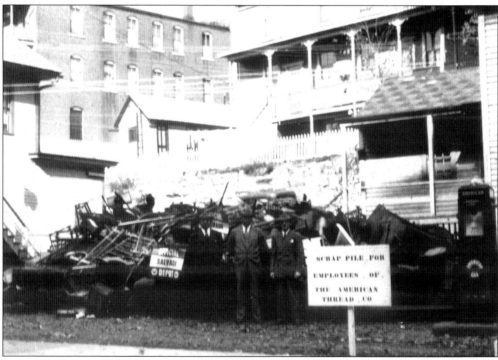

Scrap metal was collected to aid the war effort during World War II. This pile was collected from thread company employees. A 1942 townwide drive netted 35 tons of metal. The Capitol Theatre held a separate drive for children, offering a free ticket to a movie and two cartoons for each child who brought scrap metal.

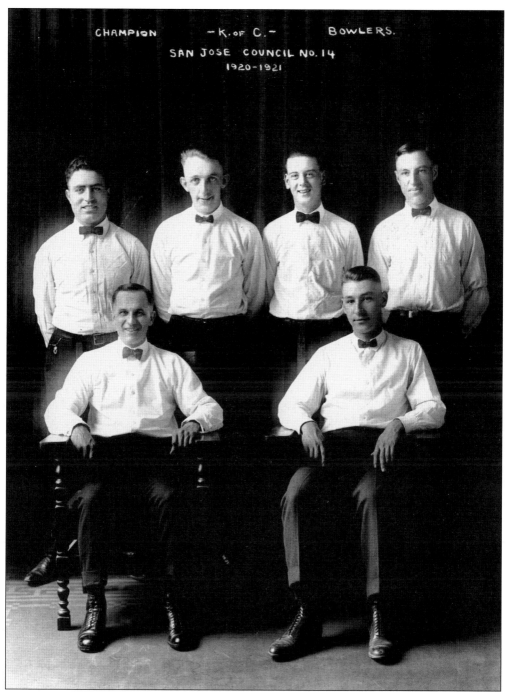

The Knights of Columbus, an organization for Catholic men, has had a long presence in Willimantic. Council 14 was instituted on March 12, 1885. This photograph shows members of the 1920–1921 champion bowling team sponsored by the council. In 1902, the local group rented space in the Hayden building. Allen B. Lincoln reported that, in 1920, the Knights of Columbus was the largest fraternal organization in town. The group maintains its own clubhouse now on Club Road in Windham.

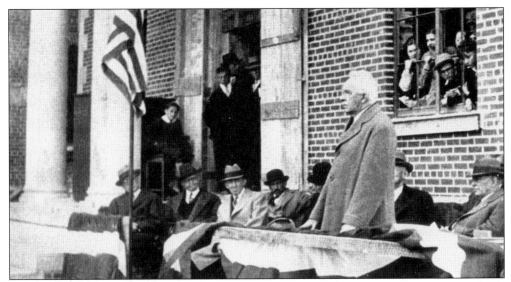

Gov. Wilbur Cross, a graduate of the old Natchaug School, returned to Willimantic in 1933 to speak as construction of the new Windham Community Memorial Hospital neared completion. Some 2,700 people contributed $500,000 to erect a modern hospital, replacing the outdated St. Joseph's Hospital. The portico is now enclosed by the hospital's atrium.

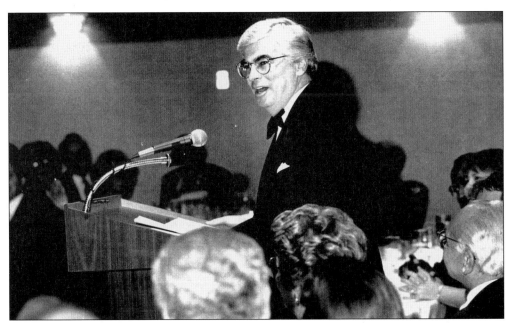

Another 100 years, another centennial. Windham celebrated its tercentennial in 1992. Sen. Christopher Dodd, a Windham native, was the principal speaker at the kickoff dinner in October 1991. The celebration culminated the following May with a picnic, a parade, a production of the *Frogs of Windham* operetta, an outdoor festival at Jillson Square, and a costume ball.

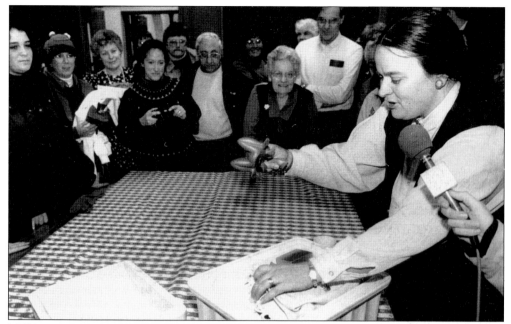

Mill Museum curator Bev York places the last item into Windham's tercentennial time capsule: a rubber frog. The frog had been used in a rubber frog race down the Natchaug River to raise funds for the tercentennial. This event was part of the closing ceremonies for the tercentennial committee, which closed up shop in December 1993.

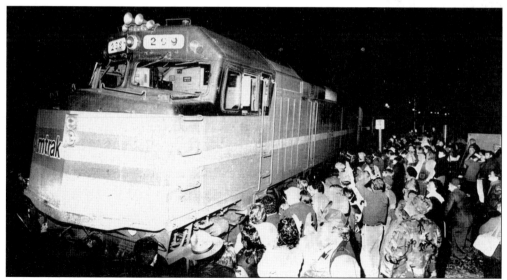

The arrival of Amtrak's *Montrealer* in Willimantic in November 1991 marked the first time regularly scheduled passenger service had been available in the city since 1955. Union Station had been demolished in the late 1950s, but that did not stop a crowd of people from turning out to see the train. A small contingent from Windham boarded for the trip to Canada. Amtrak has since ceased the service.

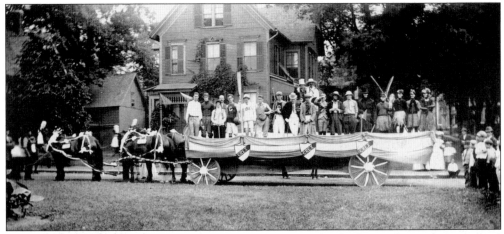

There is a long tradition of parades in town, and the Fourth of July parade in 1910 is a good example of how the whole town became involved. Above is the Grex Club on its float. In its advance story on the parade, the *Chronicle* reported the St. Joseph Polish Society would have a float, the Syrians would turn out 75 members, and the "Hebrew citizens propose to spring a surprise on the occasion."

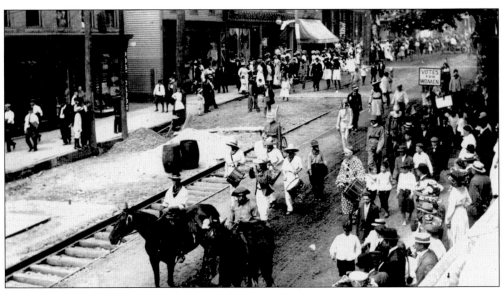

The Horribles parade proceeds down Main Street. Although this group was apparently devoted to having fun, a sign holder at the rear used the occasion to raise a serious issue. The sign reads, "Votes for Women."

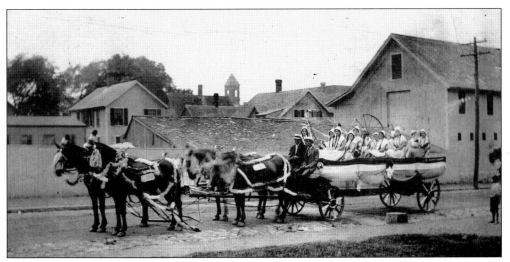

The Solidatis Club for girls from the First Congregational Church poses for a picture at the fairgrounds after the 1910 parade.

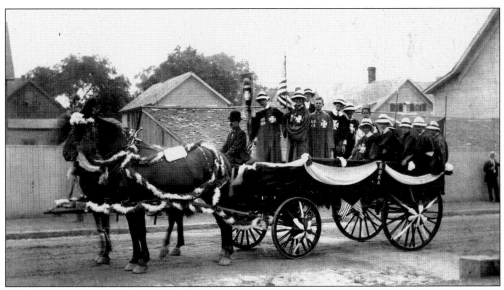

Not to be outdone, the Knights of King Arthur have put flowers along the harness and bunting on the wheels of their float. The Knights were a club for Christian boys.

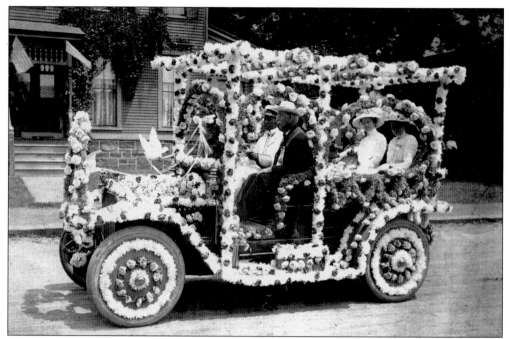

Automobiles were encouraged to join the 1910 parade, and 49 car owners answered the call. Here, H. G. Murray, the owner of the city's most popular department store, gets into the spirit of things.

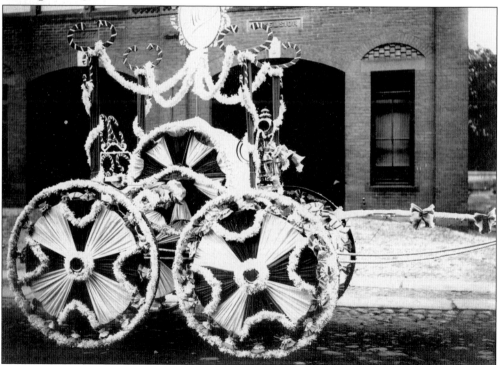

What would a parade be without a fire engine? The Alert Hose Company decorated its engine with flowers.

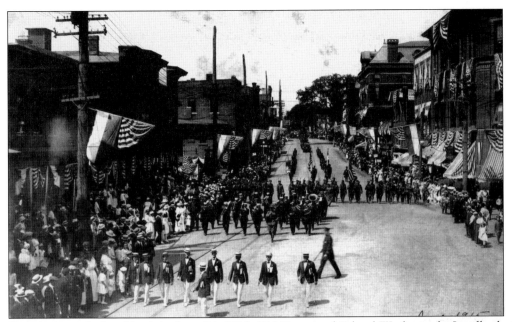

Dignitaries and a band lead the June 24, 1915, Old Home and School Week parade. Landlords and merchants went all out to ensure the city put on a good face for former president William Howard Taft, who spoke at Recreation Park at the end of the parade.

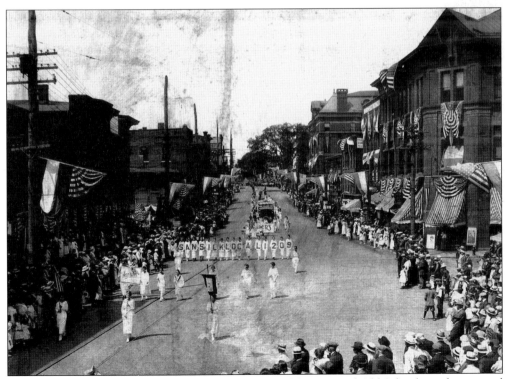

Called "Windham County's biggest celebration," the Old Home and Old School parade attracted 15,000 onlookers. In this scene, members of Silk Local 1209 can be seen in the foreground.

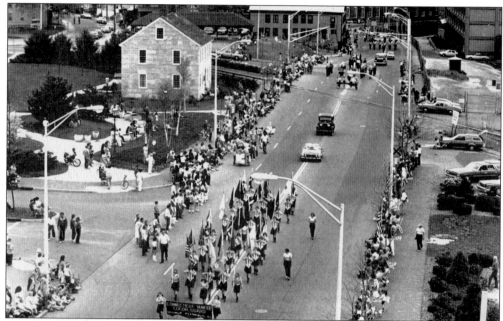

The town celebrated its 275th anniversary in 1967 with a parade. Contrary to earlier practice, this parade is marching westbound on Main Street. A color guard from Plainfield leads the way, and an antique automobile recalls earlier parades.

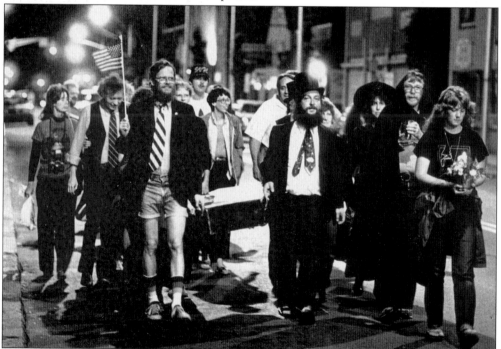

One of the oddest parades held in Windham history was the "funeral" procession up Main Street after the city of Willimantic was dissolved and reincorporated into Windham. Talk of consolidation went on for decades until voters finally approved it in 1983 and the former city of Willimantic was "buried."

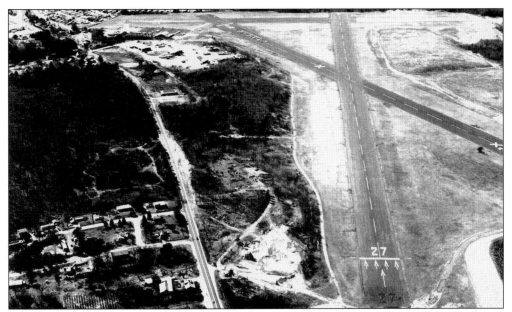

The Windham Airport provides residents and local businesspeople with easy access to distant places. The airport is situated between the artificial lake created by the Mansfield Hollow Dam and Route 6, on the left, in North Windham. Since this photograph was taken, this stretch of Route 6 has been widened and become heavily developed. It is home to Wal-Mart, Sears, and other national stores.

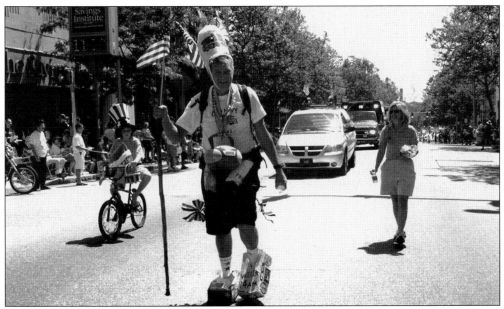

WILI Radio morning anchor Wayne Norman has been the marshal of Willimantic's Boom Box Parade since it began in 1986. When no marching band could be found, community activist Kathy Clark worked with the local radio station to devise a do-it-yourself parade. WILI plays marching music, and everyone is invited to participate.

117

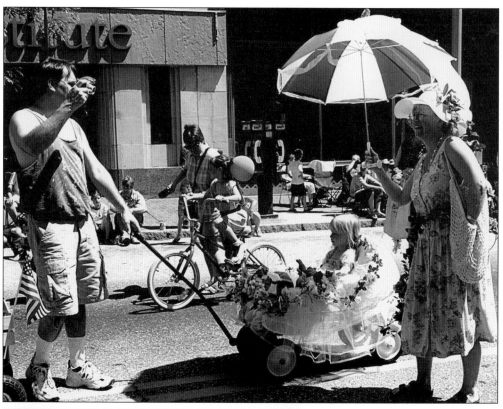

The uniqueness of the parade has attracted nationwide attention, including a feature in the *Washington Post*. Memorable units have included the precision drill team (a group of men wearing tool belts), the traveling fish heads, and the Baby Boom unit, a group of parents pushing baby carriages. Gay activists and fundamentalist churches follow one another in the parade line. No one is excluded.

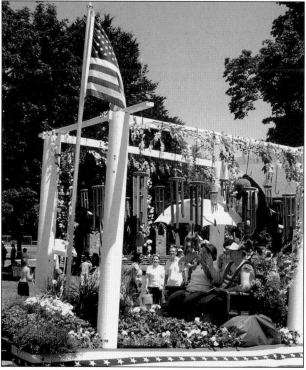

Seven

WIND, RAIN, AND FIRE

Among the victims of the Great New England Hurricane of 1938 was the iron bridge over the Shetucket River, torn from its piers by raging floodwaters and dumped unceremoniously in the water downstream.

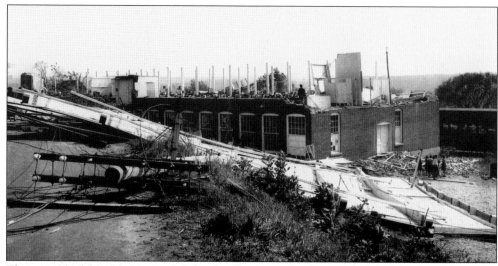

The town had barely recovered from the disastrous flooding of 1936 when the Great New England Hurricane of 1938 hit. Damage in Windham was widespread as the storm knocked out windows, toppled trees, and decapitated whole buildings. The SCS Box Company at 38 Moulton Court lost the top story of its building. One city man was killed fleeing a collapsing building.

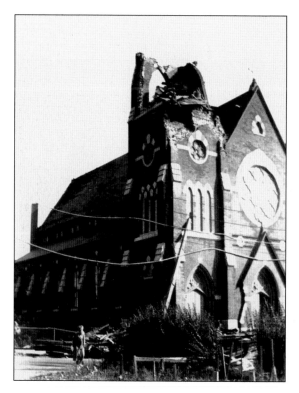

At least two churches in Willimantic lost their steeples: the Congregational church on Valley Street and St. Joseph Church on Jackson Street, shown. Repairs began almost immediately, but a new spire was not raised at St. Joseph until 1989, more than half a century after the storm. The new steeple is made from aluminum and engineered to withstand 130-mile-per-hour winds.

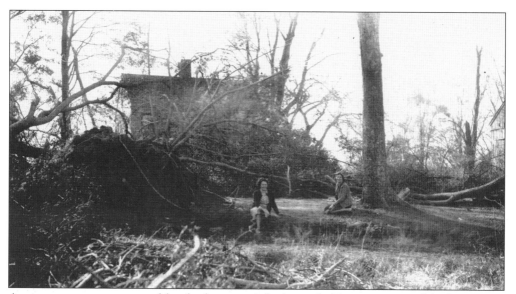

Ancient trees were uprooted by the hurricane's high winds. Two women in this photograph, taken on Weir Court, give scale to the size of the trees knocked down by the hurricane.

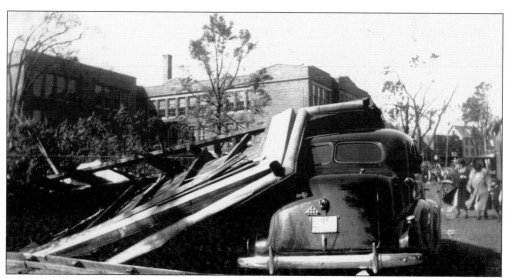

This driver had an unhappy surprise waiting when he came to retrieve his car on Milk Street after the 1938 hurricane abated.

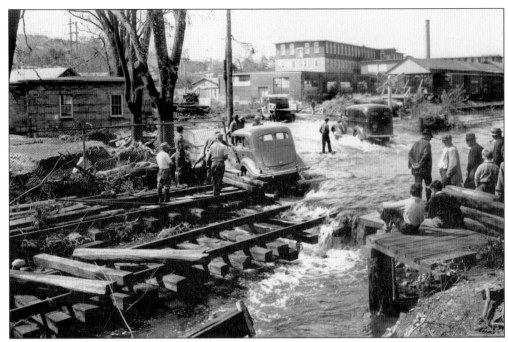

The ballast under the railroad tracks is washed out in this 1938 view of the rail crossing on Bridge Street. One driver who has managed to navigate the obstacle course heads past the former Windham Manufacturing Company. Another driver was not so lucky.

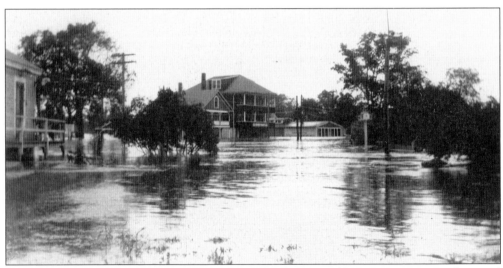

The Lower Village near Recreation Park is an island unto itself. Lower Main saw substantial flooding because it is near the confluence of the Willimantic and Natchaug Rivers. The flooding in Willimantic and downstream led to the building of the Mansfield Hollow Dam, the largest federal dam project in New England. The artificial lake created by the dam is a favorite of fishermen.

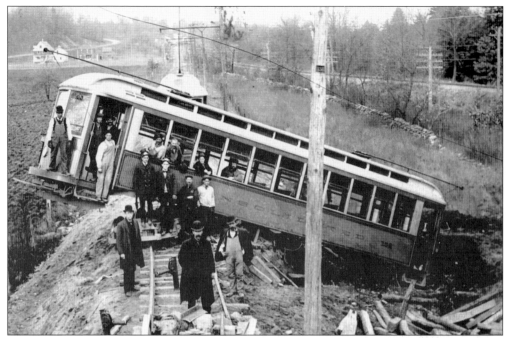

Despite the company's name, the Willimantic Traction Company, this trolley jumped the track on December 2, 1909, on Dugway Hill in South Windham. Most of the passengers were Smith and Winchester employees.

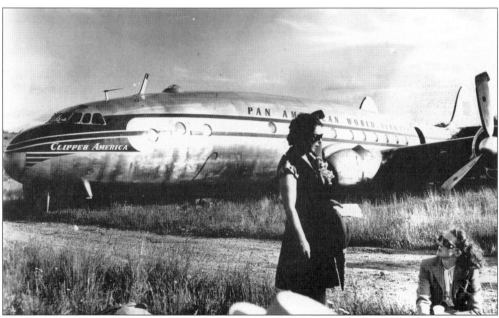

Some unexpected company dropped in on June 18, 1946, when a Pan Am Constellation bound from New York to London made an emergency crash landing at Windham Airport after an engine caught fire. Aboard were actor Sir Laurence Olivier and his wife, actress Vivien Leigh. The couple and 44 other passengers were bused to Hartford and continued on to London the next day. Too soon, Windham's day in the sun was gone with the wind.

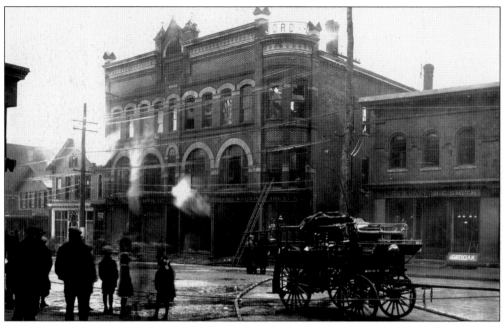

One of the city's most devastating fires took place in the Jordan Hardware block on the morning of November 22, 1916. Fred and William Jordan had bought the former Tilden and Courtney department store 10 years before. A fire engine stands on Main Street as onlookers, including several children, gather for the excitement.

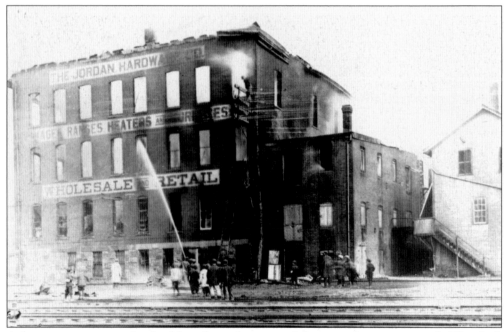

A hose company attacks the blaze from the rear of the store but to no avail. The fire's destruction caused the side wall to collapse, and officials, fearing the rear wall might fall on the rail tracks, quickly ordered it demolished.

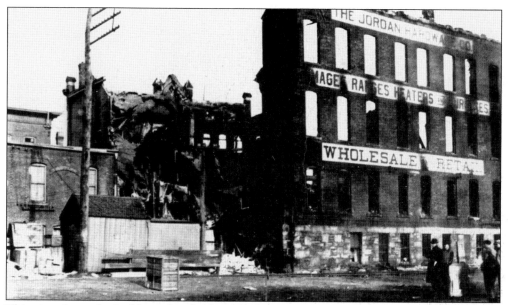

This view shows the building after the fire. While no one died in the fire, the demolition of the building killed one man and hospitalized another. A witness at the trial that followed testified the 60 pounds of dynamite used to bring down the building was excessive. The witness added that a couple of strong ropes and a good team of horses could have done the job.

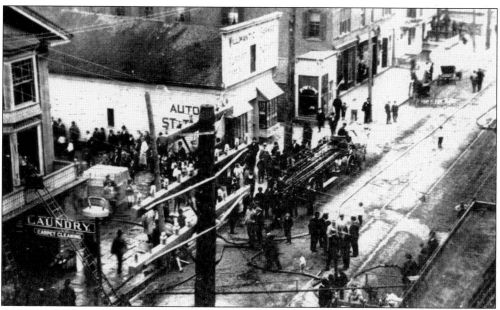

Another disastrous fire occurred in the Maverick laundry in the Melony Block, at 824 Main Street, on May 6, 1908. The fire started in the basement drying room of the laundry and was fed by clothing and rugs hung to dry. Much of the stock in the A. C. Blanchette furniture store on the main floor was scorched and burned.

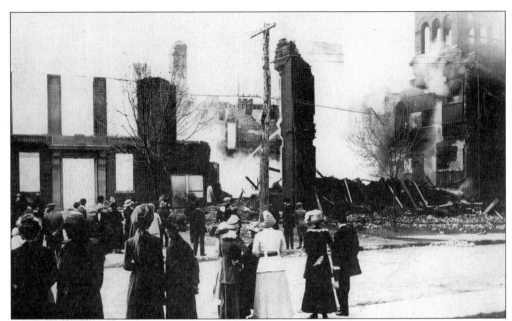

Stunned residents turned out to see the ruins of the town's new high school on April 27, 1913. The town had created a single high school in 1888 by combining grades 9 through 12 from the old Natchaug and First District schools. After the fire, a new school was built on the same spot, on Prospect Street. It is now known as the Kramer Building and houses the school board offices.

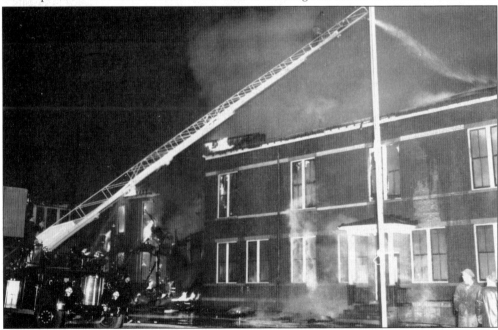

More than 100 firefighters responded on January 31, 1953, to a fire at St. Mary Parochial School. Their effort was in vain, and the school was destroyed. Less than a month later, more than $100,000 had been pledged by the community to rebuild the school, and a new building was ready two years later. In 1967, more than 300 firefighters fought a destructive blaze at the Windham Center School.

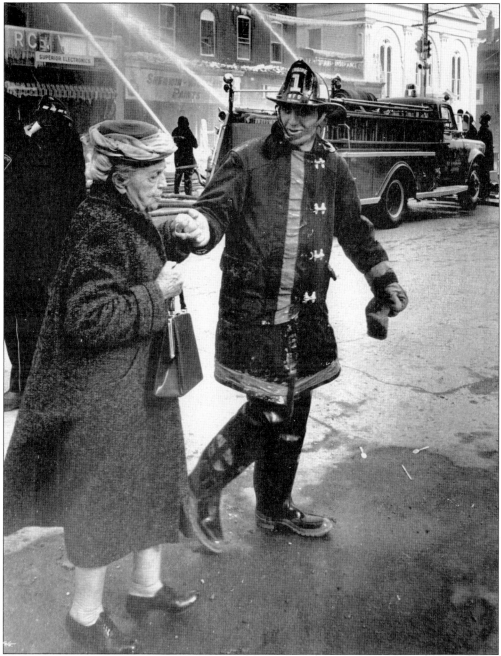

One of the worst fires was the St. Valentine's Day fire in 1968, which damaged six buildings housing 10 stores. Fed by 25,000 gallons of paint in the basement of the Sherwin-Williams store, the fire spread quickly to adjacent buildings. Eight volunteer fire departments responded to help the Willimantic Fire Department. The firefighters' job was compounded by cold weather; note the icicles hanging from the utility lines. The cause of the fire remains a mystery to this day. Despite being on the scene for nearly 24 hours, this firefighter still found time to escort 94-year-old Harriet Fenton across the street. She had walked down the hill from her Church Street home to see what all the commotion was about.

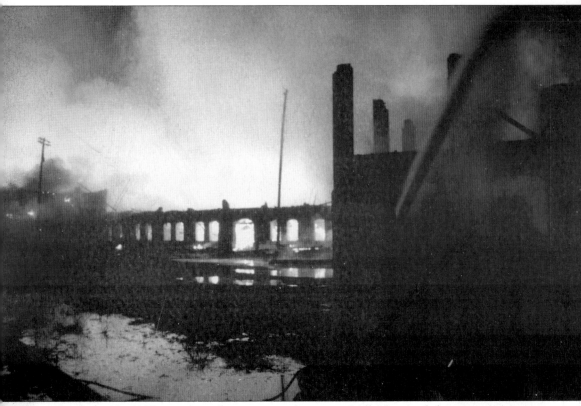

On June 10, 1995, a group of youngsters playing in Mill No. 4 of the vacant American Thread Company complex caused a fire that totaled the building. Once touted as a model for modern factories, the trend-setting building had been neglected and fallen into disrepair since the company had moved to South Carolina nearly a decade earlier. With the fire went the 1.5 million feet of lumber and 2 million bricks used to construct the 820-foot-long building.